ARKANSAS
BEER

ARKANSAS BEER

AN INTOXICATING HISTORY

BRIAN SORENSEN

Foreword by James Spencer

AMERICAN PALATE

Published by American Palate
A Division of The History Press
Charleston, SC
www.historypress.net

Copyright © 2017 by Brian Sorensen
All rights reserved

First published 2017

Manufactured in the United States

ISBN 9781467137553

Library of Congress Control Number: 2017940935

Notice: The information in this book is true and complete to the best of our knowledge. It is offered without guarantee on the part of the author or The History Press. The author and The History Press disclaim all liability in connection with the use of this book.

All rights reserved. No part of this book may be reproduced or transmitted in any form whatsoever without prior written permission from the publisher except in the case of brief quotations embodied in critical articles and reviews.

CONTENTS

Foreword, by James Spencer — 7
Acknowledgements — 11
Introduction — 13

Early Arkansas Brewers — 21
Brewing after Prohibition — 33
Laying the Groundwork — 51
Diamond Bear Brewing Company — 59
Brewing in the Ozarks — 69
Little Rock Brewers — 109
The Hinterland — 135
The Shape of Things to Come — 147

Bibliography — 151
Index — 153
About the Author — 159

FOREWORD

One of my dad's earliest memories was of hiding under the bed with his mother and baby sister as lawmen broke bottles outside their home in Hot Springs. Some of my relatives claim that my grandpa was making moonshine, but I believe it's more likely he was brewing beer and selling it to try to feed his family in the hard times of the early 1930s. Meanwhile, casinos and speakeasies were openly entertaining the crowds downtown with illegal gambling and illicit hooch.

In a way, I think this story illustrates Arkansas's schizophrenic relationship with beer and with alcohol in general. The state is split between those who enjoy adult beverages and those who literally see them as the work of the devil. Even today, according to Wikipedia, thirty-five of the state's seventy-five counties are "dry." Except for a handful of cities, retail alcohol sales are altogether shut down statewide on Sundays. The "wet" counties feature a patchwork of municipalities where alcohol sales are limited or forbidden.

For those who choose to imbibe, however, it's better than it used to be. When I was in college in the mid-1980s, you couldn't buy alcohol—even beer and wine—in Fayetteville grocery or convenience stores. Restaurants that served hard liquor had to be "private clubs," where patrons paid a membership fee and were required to sign in upon entering.

In those days, most beer consisted of essentially the same yellow fizzy stuff served in differently shaped bottles with various labels and marketing schemes attached. The colder and cheaper it was, the better. In our minds, beer came from massive factories, where the brewing process was shrouded in mystery

Foreword

and stainless steel. The thought of commercial brewing happening in the Natural State probably seemed to many as an unlikely, unachievable goal.

Imagine my surprise in reading the first chapters of this book to find that Arkansas does indeed have a long brewing heritage. It's not as deep and broad as St. Louis or Milwaukee, but there are brewing roots here. More importantly, new seeds recently planted by craft brewers are not only germinating but also bearing fruit. Our state has become home to a thriving community of brewing professionals whose hard work and artistic vision are turning our once beer-poor region into something lovers of good beer can be proud of.

My first experience with locally brewed beer was the Ozark Brewing Company, a brewpub on Fayetteville's Dickson Street. (No connection to today's Ozark Beer Company in Rogers.) Not only could patrons sample several styles of beer made on location, but they could also watch the brewmaster at work through windows looking in at the ten-barrel brewery from the dining room. Brewing had been demystified.

It wasn't long before my friend Andy Sparks, who owned the local homebrew store in Fayetteville, convinced me to take up making beer myself. Soon I was brewing and sampling styles of beer that weren't available for sale in the local liquor stores. My aspirations were never to "go pro," but luckily for us, many former homebrewers are trading in their kitchen kettles for commercial brewing systems and selling their wares as a part of the growing craft beer wave.

In many ways, the breweries of Arkansas today represent a microcosm of brewing in general. There are large production breweries that are producing a significant volume of beer and are aiming to have a regional presence, not only in Arkansas but in other states as well. Medium-scale breweries are covering the stores and taps of their local areas. Small breweries are focusing mostly on their own tasting room patrons and may have a few tap handles around town. Of course, some of the smaller players will eventually grow larger, but I think it's great that there are niches where brewers of any size can find success.

This is not to say that Arkansas has suddenly become the Colorado of the South. Fizzy yellow stuff still reigns supreme among the masses. During hunting season, twelve-packs of macro brew still come in blaze orange boxes. Convenience stores are still packed with beers that appeal more to the wallet than the palate.

However, the foothold for craft beer is secure. Once consumers get over the mental hurdle that beer is actually supposed to taste like something,

Foreword

there is no going back. Craft beer tasting rooms and brewpubs are becoming gathering places where friends can get together to try a flight of what's new or simply grab a pint of their favorite go-to ale. New employment is bringing income and tax revenue that cities are finding attractive. Disused areas of towns are finding new life. In turn, cities such as Fayetteville are spending money to promote the fledgling industry to visitors and tourists. Even in recently dry Benton County, delicious craft beer is being brewed that I believe rivals any in the country. I never thought I'd see it.

I'm glad that Brian is documenting Arkansas beer with this book. He has been reporting on the industry as it grows with excellent articles on the *Fayetteville Flyer* for the past few years. His love of the subject matter shows.

Our craft brewers deserve to step out from behind their mash tuns and canning lines and into the spotlight. I look forward to watching the Arkansas craft beer industry as it continues to grow and prosper.

<div style="text-align: right;">

James Spencer
Basic Brewing Radio

</div>

ACKNOWLEDGEMENTS

The first person I want to thank as this book reaches publication is my wife, Megan. She has endured countless brewery visits, beer tastings and festivals over the years as I pursued my interest in writing about this awesome subject. Her willingness to let me sneak off to our home office at night to put pen to paper has not gone unnoticed. Together we have three children, and I recognize that every minute together is precious. When I first met Megan in college, I knew she was the one—that we were meant to be. Through all the ups and downs that life has thrown our way, I wake up each morning knowing how lucky I am to have found her.

I'm so appreciative of the brewers and brewery owners who let me peer under the hood, so to speak, as I did the research for this book. Having covered the beer scene in Northwest Arkansas for the past several years, most brewers in that section of the state knew me and trusted what I was up to. Through the process of writing this book, however, I met many new people—brewers from Fort Smith, Hot Springs, Little Rock and small towns in between. Only rarely did I sense reluctance to participate in this project (and usually then only because of people's hectic schedule). They opened their arms to me and gave me whatever I asked of them. Most of the information presented in this book was gathered firsthand, and without the good people of the Arkansas brewing industry, it would not have been possible.

Although I really enjoy writing about beer, it's not my primary career. I've spent the past sixteen years in corporate America doing a job that I really love—one that provides a nice living for me and my family (thanks, Tyson

Acknowledgements

Foods!). I've always had a creative itch, however, and fortunately I got a shot at writing for local news source, the *Fayetteville Flyer*. It provided a platform that I didn't deserve to have and, in the process, helped me find my voice as a beer writer. What started out as simple beer reviews evolved into brewer profiles and industry commentary. The *Flyer*'s owners—Dustin Bartholomew and Todd Gill—are a big reason this project is happening now.

There are a number of people in Northwest Arkansas that taught me to appreciate beer and brewing. It's one thing to enjoy drinking beer; it's another thing entirely to appreciate the process of making it. It might sound odd to say, but my beer journey started at church. When my wife and I joined Sequoyah United Methodist in Fayetteville, I met a couple of guys who were keen on brewing. I remember attending a Sunday school party at Steve Field's house and discovering a finely crafted homebrew on tap and ready to drink. It certainly piqued my interest. I must have talked his ear off that night, getting the scoop on how he was able to make that delicious beer at home! Over the next few years, he and Ashley Goodwin taught me the art of homebrewing. They were great witnesses—in more ways than one—to quality beers made from the heart. Then James Spencer, Andy Sparks and Steve Wilkes (also from Northwest Arkansas) inspired me from afar. Podcasting was just becoming a thing when I started homebrewing, and their program—*Basic Brewing Radio*—was a lifetime's worth of experience piped directly into my earbuds. I was fortunate to get to know them personally as the years passed.

Regarding this project, I owe a debt of gratitude to Ian Beard and Leah Lambert from Stone's Throw Brewing in Little Rock. They shared in abundance the work they had done to uncover the history of brewing in the capital city. One of the great things about beer people is how open and friendly they are, and even though I was writing about a topic they had invested a lot of time and energy into themselves, they patiently walked me through their notes, interviews and other forms of research that played a big role in the early chapters of this book.

There are, of course, many others to thank—the parents who raised me, teachers who taught me, co-workers who supported me and friends who have accompanied me on life's journeys. If I listed them all individually I would run out of room or never get started telling the story of Arkansas beer. Just know that I am deeply humbled by the kindness and generosity of every single person I encountered while working on this project. The Arkansas brewing industry is full of wonderful people, and I hope you, the reader, enjoys hearing its stories.

INTRODUCTION

Arkansas occupies a peculiar place in the national psyche. Most people are unfamiliar with the state or only have a vague notion of where it is on a map. Maybe some have heard about a few famous Arkansans or a handful of big businesses that staked their claim inside the state. Bill Clinton, Walmart and the Arkansas Razorbacks come to mind, with Johnny Cash, Tyson Foods and notorious events like the Little Rock integration crisis of 1957 not too far behind. But there's just not much else out there for public consumption. The state, quite frankly, has not been a media darling through the years, and much about it goes on unnoticed.

If the state does pierce the public consciousness, it's often in unflattering ways. Situated at the crossroads between the Deep South and the Midwest, Arkansas is usually only seen through the window of a car speeding down Interstate 40. Few people actually stop long enough to develop a point of view on the Natural State (it's official nickname). So, in the space between reality and unknowingness develops a bastardized view. And sadly, it's nothing new. Cartoonish caricatures of Arkansas have been around for decades, if not centuries. The state is by unearned reputation a parody of something most people didn't even realize was a thing to begin with.

Early perspectives on Arkansas were based on unflattering stereotypes that were perpetuated by the popular media. Portrayals of lazy hillbillies and shiftless drifters dominated the radio waves and newspapers of the early twentieth century. Thomas Jackson's *On a Slow Train through Arkansas*—a popular joke book published in 1903 that was full of denigrating imagery

Introduction

of the state—came to represent the backward Arkansas lifestyle. *Baltimore Sun* satirist H.L. Mencken made a career out of poking fun. He once wrote that he "didn't make Arkansas the butt of ridicule, God did." In 1931, the Arkansas legislature responded by passing a motion to pray for Mencken's soul. Suffice it to say, he was not well-liked by the citizens of the state.

In reality, Mencken's version of Arkansas was nothing more than the biased perspective of an outsider. It was, however, a point of view that prevented many people from visiting the state for themselves. Their gullibility played right into the satirist's hands. It's a shame because there's much more to Arkansas than that hullabaloo. As revered newspaperman and Arkansas native Roy Reed wrote in his book *Looking for Hogeye*, "The visitor to the Ozarks should come not looking for mythical hillbillies asleep in the yard, but prepared to see us as we see ourselves."

How Arkansans see themselves is, of course, a complicated matter. On one hand, there is an innate sense of pride. The people who originally settled the state had a hardy work ethic. The Scotch-Irish who spread across the upland South were known for their ability to claw out an existence in rock-laden soil. Calloused hands and weathered skin were worn like badges of honor. Taming the northern hill country and draining the lowland swamps of the state's Delta region took grit and inner fortitude. It's safe to say that silver spoons were in short supply in the early days of Arkansas.

On the other hand, there is a strong sense of self-doubt embedded in the psyche of many Arkansans. The state has been picked on for so long that its sons and daughters can sometimes worry about their standing in the world. The dog whistles are hard to ignore forever.

Of course, those who truly know Arkansas understand how special it is. Arkansans aren't lazy, docile, ignorant creatures (as depicted in newspapers, books and movies through the years). Truth be told, the people of Arkansas can stand toe-to-toe with just about anyone in the world. Political giants and legends of Wall Street hail from Arkansas. And some of the most beautiful places between the Appalachian and Rocky Mountains are found there. How the state has managed to fly under the radar all these years is, quite frankly, a real mystery.

The state is incredibly diverse. Across the northern portion of the state are the lush Ozark Mountains. Beautiful landscapes are abundant there, with jewels like the Buffalo National River and Beaver Lake a short drive from the dense metropolitan core of Northwest Arkansas (the region's proper name). The state's flagship institution of higher learning—the University of Arkansas—is located in Fayetteville. J.B. Hunt, Tyson Foods

Introduction

and Walmart are established members of the Fortune 500 and provide the spark that makes Northwest Arkansas one of the most dynamic economies in the country. The once sparsely populated region is now home to more than 500,000 people. Primarily white for most of its history, it has become a diverse place that attracts people from all over the world. It claims one of the fastest-growing Hispanic populations in America and is home to perhaps the largest population of Marshallese outside the Marshall Islands.

Little Rock was the first major population center in Arkansas. The state capitol is located there, and at one time, the city provided the only true urban experience in the state. Perhaps most famous for the integration crisis of 1957, Little Rock has grown to become a diverse and integrated example of the New South. It's a sprawling city with emerging culinary and art scenes that make it an attractive place to live. Little Rock is a big city (home to over 200,000) but small at the same time. Historic downtown neighborhoods—such as Hillcrest and MacArthur Park—give it plenty of character. Its centralized location has made it an important place for politics and commerce the past two centuries. There's plenty of regional and national influence emanating from the city of Little Rock.

Beyond those two regions of Arkansas, you'll find outposts that are worth more than just a mention. To the west is Fort Smith, which was once the gateway to Indian country. The classic movie *True Grit* characterized the

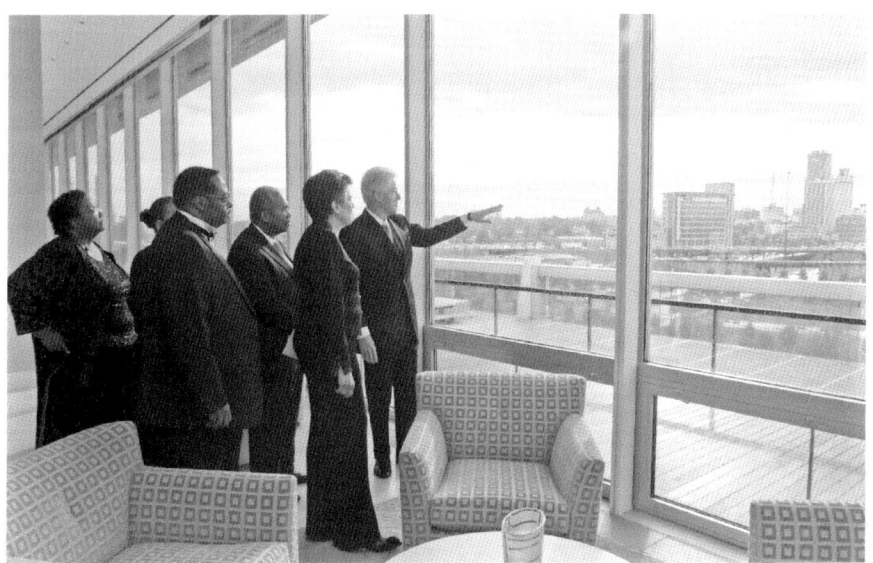

Former president Bill Clinton looks toward the Little Rock skyline with members of the Little Rock Nine. *Arkansas Department of Parks and Tourism.*

Introduction

historical ambience of the bustling border town. Pioneers of the day worked under the hot Arkansas sun by day and raised cold pints at night. Down in the Ouachita Mountains is America's original resort town. In Hot Springs, you'll find bathhouses and horse racing, along with the ghosts of gangsters, gamblers and movie stars. It was Las Vegas well before the first casino was built in Nevada. Other Arkansas towns like Jonesboro, Pine Bluff and Texarkana have their own interesting stories to tell.

Arkansans' attitudes about alcohol were similar to their southern neighbors during the 1800s and early part of the twentieth century. The temperance movement, federal taxation and Prohibition all played a role in shaping the alcohol industry inside the Bible Belt. True to the stereotypes of Arkansas, whiskey and moonshine were, for the most part, the tipples of choice. Scotch-Irish settlers found economies of scale by converting their corn crop into drink. In his book *John Barleycorn Must Die: The War Against Drink in Arkansas*, Ben F. Johnson III wrote, "In the 1890s a southern famer could make about ten dollars when he hauled his twenty bushels of corn to town, whereas distilling forty bushels into 120 gallons of whiskey could clear $150, without the federal tax." As was the case across most of the American South, farmers were better off turning their crop into a drinkable form. Of course, staying out in front of the taxman became part of the moonshiners' charge. Otto Ernest Rayburn wrote in *Ozark Country*, "Many law-abiding citizens wink at the idea of liquor enforcement in the backhills, and 'revenuers' are as unpopular with hillsmen as ticks with tourists." The rugged hills and hollers of the Ouachita and Ozark Mountains were perfect for guerrilla distilling operations.

The temperance movement found a foothold in Arkansas as the state's early leaders sought to counter the negative stereotypes associated with drunkenness. The American Temperance Society (ATS) gained a following in Arkansas, and in 1831, the Little Rock Temperance Society met for the first time at a Baptist church in the capital city. Members were called to pledge complete abstinence to intoxicating spirits. Similar organizations sprang up all over the state, affecting local governments elsewhere. Perhaps the country's most famous temperance leader—Carrie Nation—moved to Arkansas in 1908 after purchasing a farm just outside Eureka Springs. Things came to a head in 1915 when the state legislature passed the Newberry Act, effectively ending the manufacture and sale of alcohol in Arkansas, a full four years prior to the ratification of the Eighteenth Amendment.

Beer didn't have the presence and popularity that whiskey and moonshine had in Arkansas, although there were a few Germans in the state who put

Introduction

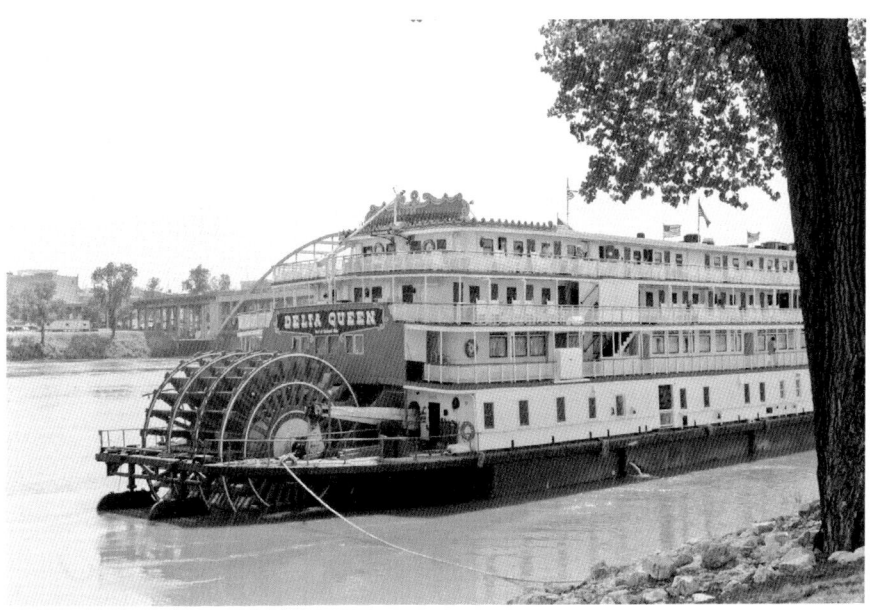

Arkansas is culturally diverse. Here the historic *Delta Queen* steamboat passes Helena, Arkansas, on the Mississippi River. *Arkansas Department of Parks and Tourism.*

their brewing skills to good use. For them, brewing was a way to make a living, just as it was for their forefathers back home in Europe. Germans set up operations in at least two major Arkansas cities in the nineteenth century. Records from those days were poorly kept, however, so it's difficult to say with complete assuredness how many breweries there really were.

There was one major brewing operation in the state's capital city at the turn of the twentieth century. Little Rock Brewing & Ice Company opened in 1898 and was quickly acquired by big industrial brewing families in St. Louis. Despite a good deal of success, the tide of temperance was too much to overcome for the brewery, and that side of the business was shuttered. Arkansas outlawed the manufacturing of alcohol ahead of national Prohibition, killing what little brewing industry there was to speak of. The ratification of the Twenty-First Amendment in 1933—which once again made alcohol lawful in the United States—did little to resuscitate brewing practices in Arkansas.

Arkansas imported beer from outside its borders throughout much of the twentieth century. The state's citizens drank industrial lagers produced in cities such as St. Louis, Milwaukee and Detroit. Industry consolidation and a widespread homogenization of taste dulled interest in local beer. Memories

Introduction

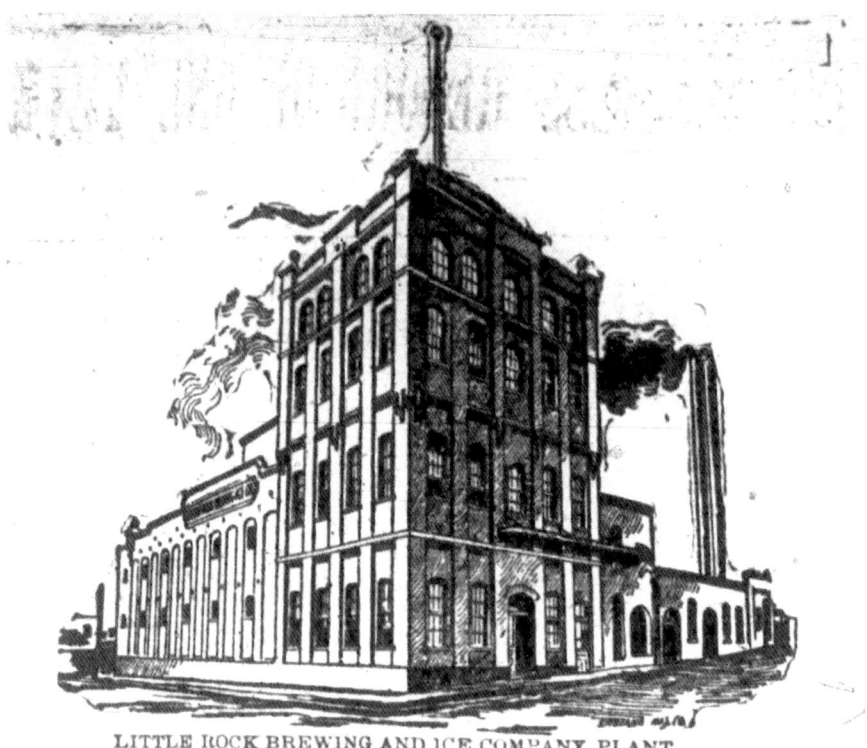

LITTLE ROCK BREWING AND ICE COMPANY PLANT.

Little Rock Brewing & Ice Company was a source of pride for the city's residents at the turn of the twentieth century. *From the* Arkansas Gazette.

of the Arkansas beer industry soon faded. Beer was a commodity—not a luxury—and it was cheaper to buy from the big manufacturers than it was to produce on a local level.

Things started to change in the mid-1980s. A few enterprising Arkansans wondered why they couldn't produce their own beer. Sending money out of state seemed like a waste, they thought. If it could work in other states, it could work in Arkansas too. In 1984, William Lyon rolled the dice by opening Arkansas Brewing Company in Little Rock—the last place beer was commercially brewed before Prohibition's death sting. It was a short-lived affair, but Lyon stoked the creative fire for people who thought beer should be a local endeavor. A few years later, Weidman's Old Fort Brew Pub opened in Fort Smith. It was the state's first modern brewpub, and it operated in the same location that a German immigrant named Joseph Knoble brewed beer more than a century before. Like

Introduction

Arkansas Brewing Company, Weidman's was only open for a short time. The first two post-Prohibition brewing ventures appeared to be ahead of their time.

The first brewery with any staying power was Vino's Brewpub in Little Rock. Vino's started making beer in 1993 and is to this day a popular destination for beer drinkers. "We're still in a new market here for specialty beers," owner Henry Lee once told homebrewers magazine *Brew Your Own*. "We're typically five to ten years behind the rest of the nation." His words still ring true when statistics from the Brewers Association are considered. The most recent numbers released by the industry's trade association show that Arkansas ranks forty-first in terms of breweries per capita (1.3 breweries per 100,000 adults over twenty-one years of age) and forty-fourth in brewery output (with 35,846 barrels). There is still plenty of room for the Arkansas beer industry to grow.

The pace of new brewery openings has quickened since the inaugural brew at Vino's. Diamond Bear Brewing Company opened in Little Rock in 2000 and was considered—for all intents and purposes—a true production brewery. (Weidman's tried to convert from brewpub to production brewery a few years earlier but collapsed amid the state's finicky appetite for craft beer and an overly burdensome cost structure.) It wasn't long before bottles of Diamond Bear started appearing throughout the state. All of a sudden, Diamond Bear was considered Arkansas's beer, and to this day it's one of the largest breweries in the Natural State.

Owner Russ Melton proved the model could work in a state that was seemingly absent of good taste. Bankers laughed at him when he presented his idea for investment. Nobody in this state, they told him, was willing to pay a premium for a product just because it tastes good. People in Arkansas drink Miller and Budweiser, by golly! But Melton pushed ahead and ultimately proved them wrong. The state's booming business climate was attracting outsiders by the boatloads. They came from places like Chicago, Cincinnati and Boston, and they brought a taste for craft beer with them. So Melton built on the small successes of those who came before him, and in the process, sparked new interest in Arkansas-produced beer.

Soon other brewers gained the confidence they needed to put their own ideas to work. Before long, new brewery projects sprang up in Fayetteville, and then a little later in Little Rock. Today, there are dozens of breweries throughout the state. They run the gamut from half-barrel breweries to large-scale brewing operations with out-of-state distribution. Some were

Introduction

started by avid homebrewers who dreamed of turning professional. Others were founded by classically trained professionals who attended some of the nation's best brewing schools.

Arkansans can hold their chins high. The state is full of great people, and the brewing industry has come a long way over the past several decades. It all started somewhere, of course. And as far as anyone can tell, it did so when a family of Germans immigrants decided to open a beer garden in their new hometown.

EARLY ARKANSAS BREWERS

Information about pre-twentieth century Arkansas brewers is extremely difficult to track down. Countless hours can be spent in museums, universities and historical society archives without finding more than a few references of early brewers in the state. Arkansas newspapers of the time were littered with advertisements for the big industrial brewers, but only a few locals received any attention. The marketing budgets of the industrial breweries were seemingly as big then as they are today—adjusted for inflation, of course.

However, based on what *can* be found, it's no surprise that German immigrants played a key role in the development of Arkansas brewing during the nineteenth century. Making beer was a tradition for them, and settling in a new land was hardly a hindrance to doing what they did best. Perhaps their biggest challenge was making beer that required fermentation temperatures somewhere south of sultry. Arkansas summers were hot and humid back then, just as they are today. Traditional lagers would have been extremely hard to brew without some sort of refrigeration aid. Somehow, some way, brewers of the day were able to accomplish their goals.

The George Brothers (circa 1840)
Little Rock

The earliest Arkansas brewers on record were the George brothers of Little Rock. Researchers from the Historic Arkansas Museum and local brewery Stone's Throw Brewing dug into historical documents to rediscover the brothers and their beer in preparation for the museum's seventy-fifth anniversary. A great source of information for them was the *Pulaski County Historical Review*. In his article "Those Enterprising Georges: Early German Settlers in Little Rock," Dan Durning wrote that early Germans "who had arrived prior to the Civil War, had firmly established themselves as valuable participants in Arkansas's economic and social life." He continued by saying, "The Germans had proven themselves to be industrious, productive, enterprising citizens." There was no finer example of the economic and social aptitude of those early immigrants than the George family of Little Rock.

Henry and Alexander George, who are believed to be the major forces behind the family's brewing operation, originally called Kelsterbach, Germany, home. They made the journey to America in 1832 with their parents, John Martin and Mary George; brothers Loui, John Martin Jr. and William; and sister, Catharina Margaretta Christina. In 1840, their father appeared on tax records as the owner of property between Commerce, Sherman, Third and Fourth Streets in downtown Little Rock. This was also the site of a beer garden known as the Little Rock City Garden. An early advertisement found in the *Arkansas Gazette* celebrated an abundance of "ice cream, wines, liquors, cake, and other refreshments." The garden regularly hosted the upper crust of Little Rock society. Today, the former site of the George brothers' brewery and beer garden is near the present-day home of Acxiom Corporation.

The George brothers themselves supplied the beer for the Little Rock City Garden. Very little is written about their brewery, but evidence of the brothers' brewing prowess can be found in the February 3, 1841 edition of the *Arkansas Gazette*:

> *Our enterprising and industrious fellow citizens, the Messrs. Georges, have fitted up a brewery on their premises. All we can say, at this early day, of their establishment is that if they continue making as good beer and ale as they do now, it will be one of the most popular, and we hope, profitable establishments in the city.*

The George family was actively involved in the Little Rock business community, with interests in banks, stores, butcheries and construction firms. In 1853, the brothers dissolved their business relationship, which led to a degree of animosity between them. Henry, who is thought to have been the primary brewer (and, according to some, more of a free-spirited creative type than he was a serious businessman like his brothers), continued to run the garden for a period of time following the split. He died in 1877.

The research conducted by the Historic Arkansas Museum and Stone's Throw Brewing not only reintroduced the George brothers to modern beer drinkers but also led to a special re-creation (or close approximation) of a beer the George brothers may have brewed back in their day. Researchers pored over newspapers from the time in an effort to understand the types of ingredients that were available to brewers then. They also considered the type of beer that was brewed in the Georges' hometown of Kelsterbach, Germany. Being that they were from a warmer area of the country, it was assumed that their beer would have been similar to warmer-fermented farm ales familiar to present-day ale drinkers. Wheat, buckwheat, oats and barley were used in the re-creation, along with a wild strain of yeast harvested from nearby Dunbar Community Garden. A touch of Arkansas honey was also added to lend a subtle sweetness to the finished product. In total, one hundred gallons of "Historic Arkansas Ale" were kegged for the museum's anniversary celebration in July 2016. It's hard to say if it was a 100 percent faithful reproduction of the George brothers' beer, but it was definitely a hit with those who sampled it.

A few other German immigrants—from places like Baden and Bavaria—are listed as brewers in the 1860 and 1870 state censuses, but there is nothing written about them beyond those records. It's probably safe to assume that many more made beer, with some selling it for profit. But information is sparse (or, more accurately, nonexistent), and we are simply left to make assumptions.

JOSEPH KNOBLE (1848–1881)
Fort Smith

One brewer who did leave a legacy was located on the western fringe of Arkansas in Fort Smith. Joseph Knoble was an immigrant from Wittenberg, Germany who settled in the city, which was at the time a federal outpost

on the border of Arkansas and Oklahoma. Back then, Fort Smith was the gateway to Indian country, and for many years, it was the home of the busiest district court in the United States. Between 1873 and 1896, a total of eighty-six men were sentenced to hang on the gallows behind the courthouse (today, the collection of buildings and artifacts is a part of the National Park Service). All of the men executed were convicted of rape or murder, with each charge carrying a mandatory death penalty. Judge Isaac Parker—the famous "hanging judge" of Fort Smith—was responsible for seventy-nine of the executions.

Fort Smith was a rough-and-tumble town during those times, and there were several saloons that catered to the thirst of outlaws and lawmen alike. Enforcing the law in such an unruly town surely led to parched throats along Garrison Avenue (which was at the time the heart of Fort Smith). To meet the need, Knoble set up shop just a few blocks away from what would later become Judge Parker's court. Proximity to the hustle and bustle of downtown Fort Smith would have been highly favorable for business.

The consensus among historians is that Knoble built his brewery in 1848. It was constructed on the side of a hill at the corner of North Third and East Streets, near the Arkansas River in downtown Fort Smith. It was built with stone and consisted of three stories and several distinct features throughout the property. The third floor was where the majority of the brewing process was performed. Barley was spread on the floor and malted by sprinkling it with water. Once the grain started to sprout, the barley was tossed in the air with shovels to stop the germination process. The newly malted grain was then mashed, boiled and fermented on the third floor before it was drained through pipes to kegs waiting on the second floor of the brewery. Due to the grade of the property, the outdoor beer garden was located just off the second floor.

A beer cellar was built underneath the beer garden and was connected to the main structure by a tunnel. The cellar was approximately thirty-five feet long and fifteen feet wide, with a convex ceiling measuring ten feet at the center. The cooler temperatures of the cellar were bolstered by ice chipped from the nearby river during the winter and dropped down a chute in the ceiling. Legend has it that treasures obtained from the Civil War are still buried under the floor of the cellar. Some claim that a worker who assisted in the construction of the brewery is buried there as well.

An indoor beer hall was located on the first floor at street level. Evidence points to Knoble's brewery as being a boisterous place, full of merrymakers on most nights.

Early Arkansas Brewers

Left: The Joseph Knoble brewery is listed in the National Register of Historic Places. *Brian Sorensen.*

Below: The old brewery is now home to popular steakhouse Doe's Eat Place. *Brian Sorensen.*

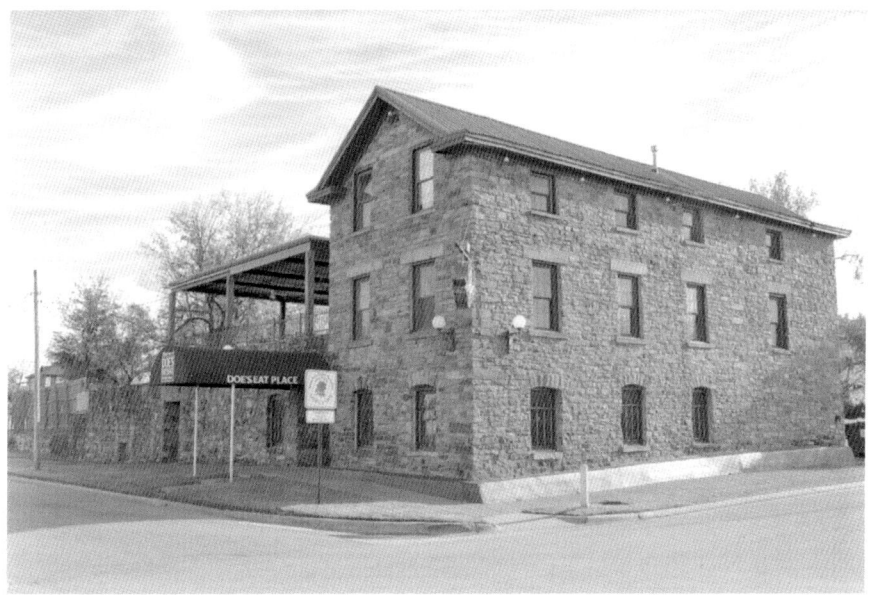

Little is written about Knoble's beer, but there are a few anecdotes on record about Joseph Knoble the man. In addition to being a brewer, he was by trade a stonemason. He was a member of the Belle Point Guards of Fort Smith, a pro-secession infantry group composed entirely of German Americans during the early Civil War years. In 1874, a mortgage lender sued Knoble for failure to pay the note on his property, which included the brewery and a house. According to records from the Supreme Court of Arkansas, he "slept in the brewery, not, it seems, for want of room in his house, but on account of the business, and because he did not live pleasantly with his wife." We are left to wonder if it was his decision or hers. Unfortunately for the Knoble family, the court ruled in favor of the plaintiff and ordered a foreclosure on the property. It's not clear how he did it, but Knoble was able to maintain his brewing operation for several more years following the ruling.

During the brewery's heyday, Knoble sold his beer at the brewery and delivered to more than thirty businesses in downtown Fort Smith. "Nickel Kate," who earned her nickname by selling Knoble's beer for a nickel in the brewery's beer hall, served a loud and boisterous crowd. Fort Smith was home to many Germans back then, and they would have found comfort in the familiar beer of Knoble's brewery. Thanks in part to German support (and despite the aforementioned foreclosure), the brewery stayed in continuous operation until Knoble's death in 1881. He is buried alongside his wife at Fort Smith's Catholic cemetery.

After Knoble's passing, the brewery was used as a residence and, for a time, a grocery store. It sat vacant for years as downtown Fort Smith aged and businesses migrated east down Garrison Avenue. Then, in 1960, Mrs. Carl Wortz Jr. purchased the brewery for her husband as a Valentine's Day gift. Carl Wortz, whose father founded the Wortz Biscuit Company in Fort Smith in 1885, was an enterprising man, and his wife thought he could put his energy into restoring the old brewery. For nine months, he poured his heart and soul into restoration efforts in an effort to re-create Knoble's operation. The brewery served as a museum for many years, lovingly curated by Wortz. It housed many artifacts, including brewing equipment and other Wortz family memorabilia. It was eventually sold to the Weidman family, who opened the state's first modern brewpub in the building in 1992. It is now home to Doe's Eat Place, a popular steakhouse franchise with locations throughout the Mid-South. The building is well preserved and harkens back to the days of Joseph Knoble, serving as a stunning reminder that the brewing industry in Arkansas is older than most people think.

LITTLE ROCK BREWING & ICE COMPANY (1898–1915)
Little Rock

Arkansans continued to thirst for beer, and a few years after Knoble's death, another brewery emerged in the state. In 1898, the Little Rock Brewing & Ice Company opened for business under the leadership of Phillip Hildenbrand, the company's first president. It was located at the corner of Second and Bird Streets near the present-day home of the William J. Clinton Presidential Library and Museum. According to newspaper reports, the brewery had an initial annual capacity of forty thousand barrels per year.

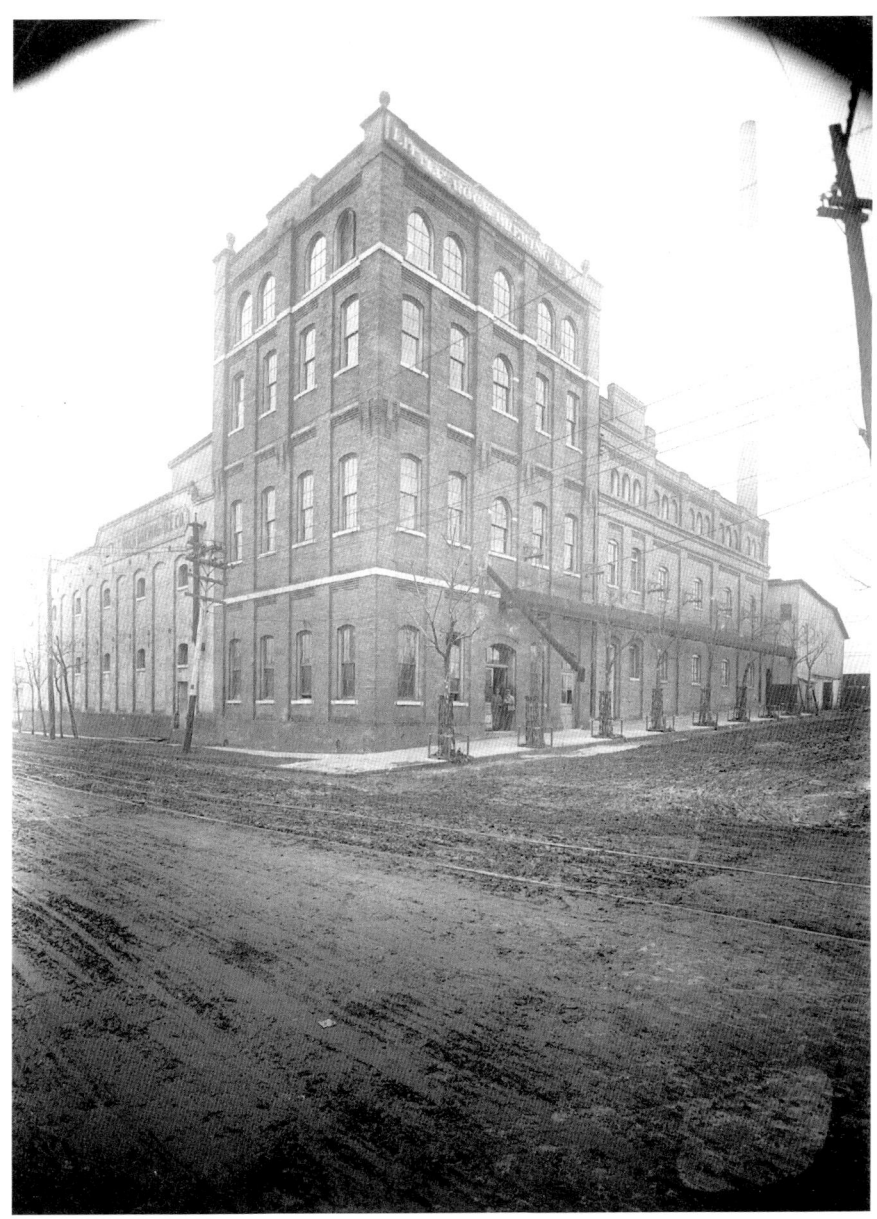

Little Rock Brewing & Ice Company opened in 1898 and was located at the corner of Second and Bird Streets. *Butler Center for Arkansas Studies.*

Little Rock was then home to nearly thirty-eight thousand people and was by far the biggest city in the state. Electric street lighting and streetcars were introduced in the years immediately preceding the brewery's arrival. Little Rock was emerging as one of the prominent cities in the American South. The brewery's ice plant was capable of turning out thirty tons each day to keep up with the growing population. Assisting Hildebrand with the operations of the brewery and ice plant were John Blackwood as vice-president and John D. Doyle as secretary and treasurer.

The company changed hands two years after opening. In a story dated April 13, 1900, Doyle told the *Arkansas Democrat*, "We got a satisfactory price for the plant, and the new company will proceed on the same lines we were following." According to the story, W.J. Lemp and Adolphus Busch took ownership of 2,055 and 2,015 shares in the new brewery, respectively. This was a significant event in the history of Little Rock, as two major brewing families from St. Louis poured money into the hometown brewery. The W.J. Lemp Brewing Association started in the Gateway City around 1840 and grew significantly over the next several decades. It is widely believed to be the first brewery to distribute its product coast to coast, and by the mid-1890s, it had become the eighth-largest brewer in the country. Busch was the co-founder of Anheuser-Busch, which would champion the industrial lagers that monopolized the American beer industry for more than a century.

Although it is reasonable to think there was local anxiety over the deal—especially given the fact that "northern" money was being used in the purchase—there was also a great deal of excitement about what the infusion of capital would do for the brewery and its hometown. Real estate surrounding the brewery was purchased as a part of the deal. The brewery was expected to expand as the demand for its beer ramped up. "The new company intend [*sic*] that the Little Rock Brewery shall become in every particular the best brewery in the south," a reporter noted in the *Arkansas Democrat*. "It will be pre-eminently a home enterprise, and its various ramifications will add very materially to the wealth and business of the community."

Native of Germany and local banking executive Nick Kupferle was appointed the new president of the brewery at the time of acquisition, and Louis Lemp was named vice-president. Hildebrand remained involved in the brewery as superintendent for a short time. He eventually returned to his hometown of Philadelphia and was replaced by Emanuel Schneider, a German immigrant who moved to Little Rock from Columbus, Ohio, to run the brewery's day-to-day operations. Schneider had more than twenty years of brewery experience before accepting the

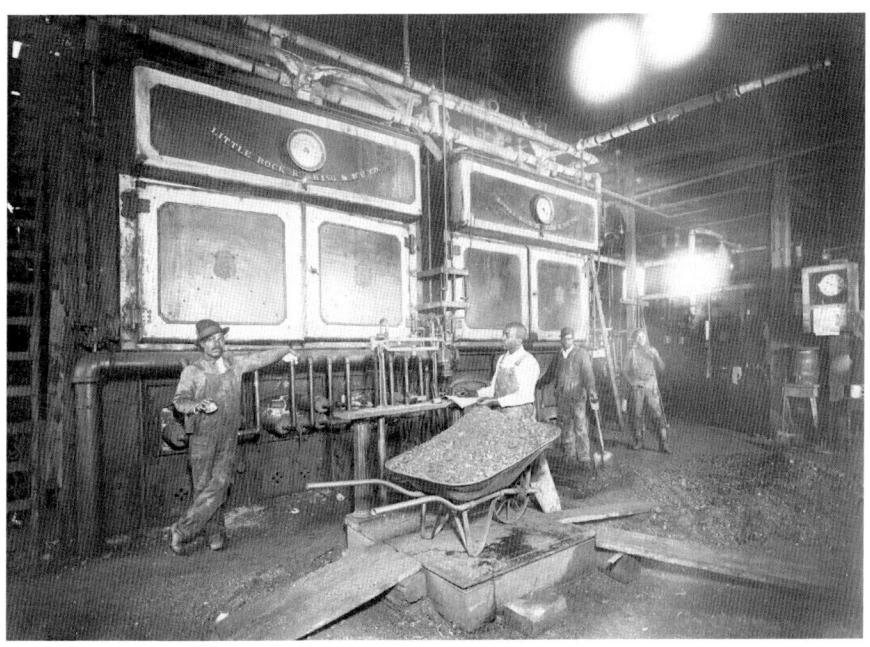

African Americans played roles in brewery operations. *Butler Center for Arkansas Studies.*

Kegs are filled at Little Rock Brewing & Ice Company. *Butler Center for Arkansas Studies.*

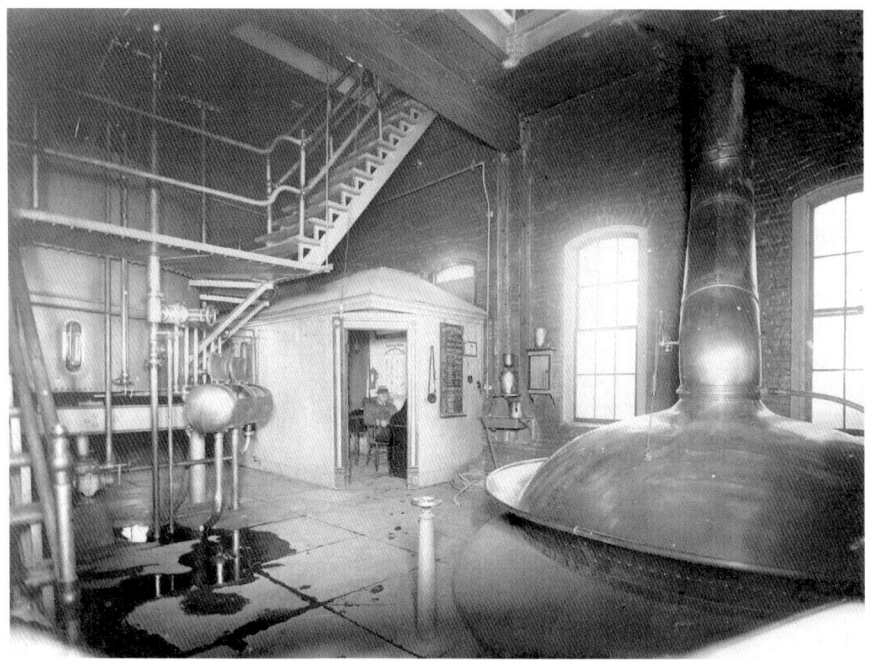

The top of Little Rock Brewing & Ice Company's boil kettle is visible in the foreground. *Butler Center for Arkansas Studies.*

job in Little Rock and made quite an impression on the city's residents with his brewing expertise. The state's newspapers spoke glowingly about Little Rock Brewing & Ice Company's beer after his arrival, with the *Arkansas Gazette* noting on November 17, 1901, "The bottled article is simply perfection. It cannot be surpassed. It is not only pleasant, but wholesome, and is just the beverage for family use," as well as, "They say that Little Rock beer is just as good as any beer that is made; that it is better than the majority of brands of beer, and, this being the case, they can find no excuse for not buying the home product."

In 1902, brewery officials reported that profits from the acquisition had not been distributed to shareholders. The money was instead reinvested in the brewery in the form of equipment upgrades, such as a massive mash kettle, bottling line and keg-cleaning machine. Additional improvements were made in 1906, with the addition of a fermenting cellar, a lagering cellar (where the beer would be stored for a period of eight to ten months) and filtering and racking equipment. Newspaper advertisements extolled the benefit of the brewery's spent grain as

Men stand between massive vats of beer at Little Rock Brewing & Ice Company. *Butler Center for Arkansas Studies.*

feed for cattle and hogs. During its heyday, Little Rock Brewing & Ice Company employed fifty-eight people, and its beer—Baeren Brau and Pilsner Extra Pale—could be found in nearly every bar in the city.

Despite the brewery's strong leadership, its outstanding capital structure and its popularity in the home market, it would eventually fall victim to the growing influence of the temperance movement, and ultimately to the outlawing of alcohol manufacturing in the state. Little Rock Brewing & Ice Company closed in 1915, marking the end of a remarkable chapter in Arkansas's brewing history. It would be many, many decades before another brewer fired up a kettle in the state.

BREWING AFTER PROHIBITION

The end of Prohibition was not a significant event for the Arkansas beer industry. Temperance attitudes remained entrenched in the local communities, and many counties in the state voted themselves altogether dry. To this day, Arkansas remains a patchwork of wet and dry counties. Arkansas was for the most part unfriendly to brewers by severely limiting output and requiring participation in the three-tier system of distribution. Local brewers were essentially squeezed out as the big industrial brewers exerted their influence over local distributors. While probably not a situation unique to Arkansas, it certainly didn't help any local beer brands find footing in the Natural State.

There was a small number of brewing startups in the years that followed Prohibition. Curiously, none of them actually brewed any beer. They were just ideas that never gained any traction. It wasn't until the 1980s that wort finally fermented again in Arkansas.

Arkansas Brewing Company (1984–86)
Little Rock

In 1984, William Lyon and partner Scott Riley rolled the dice on a beer they called Riley's Red Lyon—a malty English-style ale that was quite different from what Arkansans were used to drinking back then. Most people in the

state were big fans of fizzy yellow lagers. Anything outside the norm was sure to turn up noses. For nearly three years, Lyon and Riley tried to change the drinking habits of their fellow statesmen. Unfortunately, they were still a decade or two ahead of their time.

William Lyon was born in a small town and aspired to do big things. Growing up in El Dorado, Arkansas, he looked north for opportunity, which he found at the University of Arkansas in Fayetteville. "I hitchhiked up there," said Lyon. "I was so stupid I didn't know it cost money to go to college." All of his friends attended school in Fayetteville, so he thought he should do the same. While in college, he was the president of the Sigma Nu fraternity and studied business. When he wasn't buried in his books, Lyon spent time unwinding at George's Majestic Lounge, a Fayetteville drinking institution.

Today, George's, which sits next to the Arkansas & Missouri Railroad on Dickson Street, is the oldest and longest-running club and live music venue in the state. In its early years, the bar was a popular hangout for university students and faculty. They were notorious for tossing empty beer bottles against passing trains and for generally having a good time when classes were not in session. Lyon created many of his own memories while hanging out at George's, including one near-death experience (or so he thought). "Me and a friend were in there one Saturday afternoon," he said. "We looked up and a truck was backing up to the place. We almost tore the place apart trying to get out of there because we thought it was a railroad car that got slung off the track. We'd had a few too many, I do believe."

After graduating from the University of Arkansas, Lyon put his business degree to work in several different ways. Some might say he was multifaceted; others might call him a true Renaissance man. Early on, he owned a tie mill and a paper products operation. He later moved to Fordyce, Arkansas, and bought a concrete plant. The city was going through a growth spurt, and Lyon was positioned to make a profit in the construction boom that was taking place. Five years later, he decided to run for mayor. He didn't win that particular election, but he would go on to win the next in 1971 (soundly defeating the man who had previously beat him). Lyon served four years as mayor of Fordyce before returning to private business.

By the early 1980s, Lyon was thinking about his next business venture. Scanning the local newspaper one day, he read about a man named Scott Riley who was trying to open a German restaurant and brewery. Unfortunately for Riley, microbrewery restaurants—or brewpubs—were still illegal. Lyon sensed an opportunity and decided to contact Riley to

gauge interest in a partnership. "I tried his beer and it was very good," remembered Lyon. He believed strongly enough in Riley's brewing abilities to move forward. The pair formed Riley-Lyon Inc. in June 1983, and work got underway on what they eventually called Arkansas Brewing Company.

Equipment was extremely difficult to find back then. Microbreweries were few and far between, and tanks, kettles and other brewing necessities were in short supply in the secondary market. Much of what was eventually installed at Arkansas Brewing Company was custom made. Some of it was retrofitted equipment that was originally built for other purposes. "It cost a good deal to build the stainless steel tanks," said Lyon. A decades-old labeling machine was purchased from a defunct soda bottler in nearby Arkadelphia. In total, more than $300,000 was spent piecing together the brewing operation.

Little Rock residents were excited to have their own brewery. The location on Cantrell Road—near popular restaurant Cajun's Warf—gave Lyon and Riley the kind of visibility that helped Arkansas Brewing Company attract attention. "They all wanted to come and see the brewery," said Lyon. Nothing like it had existed in a generation, and there was a real sense of optimism about the project. Lyon gave interviews to anyone willing to listen. He called himself a "redneck entrepreneur from Fordyce," and people were fascinated by the idea of drinking his beer.

In the spring of 1984, the brewery attended the Great American Beer Festival in Denver, Colorado. The event was created by homebrewing legend Charlie Papazian in 1982 and was the place for members of the fledgling craft beer industry to gather and celebrate. Going to GABF was a big deal for Arkansas Brewing Company. Riley's Red Lyon placed seventh among seventy beers entered in the competition, although by Lyon's account, the brewery placed first in terms of who had the most fun. "Anytime a lady would come up and get a sample of beer we'd pat her on the butt," he said with a chuckle. "It got to be where they'd come up just to get their butts patted."

Things weren't always fun and games for Arkansas Brewing Company. There were several quality issues over its short lifespan. Bacterial infections threatened the brand's reputation. At one point, Lyon called in a microbiologist from the University of Arkansas to troubleshoot the brewing process. "We never did figure it out completely," he said, quite disappointed. Despite problems with quality control, Arkansas Brewing Company pushed forward. White Tail (a lager brewed with Arkansas rice) and Ten Point Beer (another lager) were sold in the local market and developed a respectable

following. Any Arkansan familiar with Arkansas Brewing Company will likely remember one or both of those beers.

Distribution proved to be even more challenging than quality control for the young brewery. In those days, the state's brewers were prohibited from distributing their own beer. Distributors were wholly focused on the major national brands and, according to Lyon, often engaged in nefarious practices to prevent smaller breweries from accessing the market. "We had a tremendous amount of trouble trying to distribute our beer," said Lyon. "And once we actually got a distributor to put our displays in stores, other distributors would tear them down."

The year 1986 was a tough one for Arkansas Brewing Company. The brewery was selected to brew a special beer for the state's sesquicentennial celebration, which commemorated Arkansas's official statehood 150 years earlier. Unfortunately, officials from the Alcoholic Beverage Control Division demanded the beer removed from shelves because it had been delivered to market with an unapproved label. The brewery was also guilty of packaging the bottled beer in pairs, which was a clear violation of ABC standards. The beer was immediately pulled from shelves, and was essentially (if not literally) poured down the drain. The financial setback was too much for Lyon and his partners to bear. So, after two and a half years and investments totaling more than $800,000, Arkansas Brewing Company closed its doors and the business folded.

October 1986 marked the end of an important chapter in the state's brewing history. Not since before Prohibition had an Arkansas brewer made beer for public consumption. Somebody had to pave the way for the industry's reemergence. Arkansas Brewing Company played that role for all of the breweries that followed. After closing, Scott Riley moved on to other out-of-state brewing jobs, and William Lyon went back into politics and served several more terms as mayor of Fordyce. The self-proclaimed "redneck entrepreneur" is currently enjoying retirement there.

Weidman's Old Fort Brew Pub (1992–2002)
Fort Smith

They say history is famous for repeating itself. Such was the case when Weidman's Old Fort Brew Pub opened for business in June 1992. The Weidman family made beer in the very same building Joseph Knoble once

brewed in a century before. And like Arkansas Brewing Company, Weidman's was perhaps ahead of its time. It did help usher in the modern brewpub era in Arkansas, however.

Weidman's was a family venture led by Bill Weidman. He was a chemical engineer who moved his family to Fort Smith from Kansas City several years before the brewpub idea occurred. He and his wife, Peggy Weidman, had five sons. Bill Weidman eventually sold his business, wanting to start something that he could do with his boys. Having previously dabbled in homebrewing, he decided that professional brewing would be a worthwhile endeavor. A major hurdle for the Weidman family was the archaic nature of beer laws in Arkansas. Severe volume limits and the three-tier system prevented would-be brewers from selling and distributing their beer. Profitability was difficult to achieve in such an environment. Things started to change when the state's microbrewery restaurant law, written in 1991 with input from the Weidman family, went into effect. It allowed a microbrewery restaurant—or brewpub—to brew beer for onsite consumption. Getting beer past the national brand–controlled distributors and into consumers' hands was no longer an issue.

With legal obstacles out of the way, the Weidman family was free to move forward. Three of the five sons played critical roles in the new brewpub. Terry Weidman had been to culinary school in Vermont and was in charge of the kitchen. Shaun Weidman was responsible for the books. Brewing duties were assigned to Daniel Weidman. Why was he chosen to play the brewing equivalent of lead guitar for the new brewpub? "I was the smartest and the best looking of the five brothers," he said, playfully. The newly named brewer soon shuffled off to Chicago to attend an acclaimed brewing school, the Siebel Institute of Technology. Daniel Weidman spent several weeks learning about the technical aspects and other nuances of the brewing process. He lived in a hotel next to an interstate, hundreds of miles away from the relative small-town atmosphere of Fort Smith. Watching the nightly news in Chicago was an anxiety-laden affair, with crimes and murders documented in huge numbers. He was ready to go home and start brewing. While in Chicago, Daniel Weidman met John Gilliam, who was then an employee of Siebel. Coincidentally, Gilliam later moved to Fayetteville, Arkansas, and opened a brewpub of his own.

Daniel Weidman spent a few months at West End Brewing Company in Dallas, Texas, after finishing his coursework. Although he wasn't at West End for long, he did get the opportunity to spend some time with Dr. George Fix, author of *Principles of Brewing Science* and an icon in amateur and professional

brewing circles. "I got to brew with him in his garage," said Daniel Weidman. The experience in Dallas allowed him to work on a commercial brewhouse and gain much-needed experience before heading home.

Back in Fort Smith, a deal to purchase the old Joseph Knoble Brewery was in the works. Carl Wortz had restored the brewery to its former glory following many decades of neglect. The Weidman family was intrigued by the novelty of running a modern brewery there. The deal closed, and the Weidmans started outfitting the old building for their new brewpub. "The building took quite a bit of work to get it ready for brewing," said Daniel Weidman. Flagstones were laid on the first-level floor, and many other upgrades were made prior to opening day. All of the brewing equipment was locally fabricated. A seven-barrel brewhouse was installed. Much like Joseph Knoble had done in the 1800s, the Weidmans used gravity to move liquid through the brewing process. The grain mill, hot liquor tank and mash tun were located on the top floor, and the kettle and boiler were located on the second floor. Wort was sent to two primary fermenters in a walk-in cooler on the first level. Four secondary fermenters and six storage tanks were also kept inside the cooler.

Working at the brewpub was labor-intensive. Employees unloaded fifty-pound bags of grain from trailers parked beside the brewery. They hiked the heavy sacks one hundred yards up a hill and then ascended three flights of stairs to the brewery's top floor. Daniel Weidman said that an abundance of blood, sweat and tears was shed at the brewpub during its short existence.

When Weidman's Old Fort Brew Pub first opened, beer was sold exclusively on site due to state restrictions. Those rules would relax several years later, but in those early days, it made for a lively environment inside the brewpub. "We had great crowds," said Daniel Weidman. "We were a destination, and people came from all over." The outdoor beer garden was particularly popular when the weather allowed for its use. Plunger darts—a game in which toilet bowl plungers were moistened with water and thrown at a target—was frequently played there. One of the first beer festivals in the region was held in the beer garden on March 12, 1994. More than fifteen breweries attended the first annual Mid-South Beer Festival,

Weidman's Old Fort Brew Pub occupied the old Joseph Knoble brewery when it opened in 1992. *University of Arkansas–Fort Smith.*

Brewing After Prohibition

including 75th Street Brewery from Kansas City; Waterloo Brewing Company from Austin, Texas; and Louisiana's Abita Brewing Company. Weidman's beer proved just as popular as beer from outside the state. "Our most popular beers were our stouts," said Daniel Weidman. "Another awesome beer was our smoked porter. We had the guys up at Ozark Mountain Smokehouse in Fayetteville smoke the barley for us while they were smoking their meats."

Eventually, the Weidman family tired of eighty-hour workweeks and in late 1995 decided to drop food altogether to focus on packaging. Another cooler was added, and a larger tank was built to bottle from. Most of the bottling took place in what was previously the kitchen. Weidman's Old Fort Brewery, as it became known, continued to operate in the old Knoble brewery until 1997. It then moved to a larger facility at 708 North Thirty-First Street, just a few miles away from the original location. The larger warehouse space allowed for the installation of a twenty-one-barrel brewhouse purchased from a brewery in Lafayette, Louisiana, that was closing down. The revered beer writer Michael Jackson visited Weidman's after the move and wrote on his blog that his "favorite among their beers is their nutty, chocolatey, dry, Danny Boy Stout." Other beers packaged by Weidman's were Arkansas Ale and Rope Swing Red Ale.

Weidman's continued to bottle beer for distribution until 2002, when it closed amid a somewhat gloomy market for Arkansas-produced beer. Daniel Weidman said that one of the challenges facing microbreweries of the time was the lack of proper handling by distributors and retailers. Once beer left the brewery, it was often stored warm and displayed in sunny beer store windows. This wreaked havoc on the quality of the beer. By the time it reached consumers, it hardly resembled the beer that originally left the brewery. And because it was made with higher-quality ingredients, it cost more than big-name brands at retail. Thirty-packs of nationally branded lagers were cheaper than six-packs of microbrew that might have been skunked due to poor handling. This combination of factors spelled doom for many small brewers of the time, including Weidman's Old Fort Brewery.

Weidman's made its mark on the Arkansas brewing industry with nearly a decade in business. The family played a key role in making brewpubs legal

Weidman's Old Fort Brew Pub was the state's first brewpub after they were legalized in 1991. Brian Sorensen.

in the state and provided Fort Smith beer drinkers a place to try new and unfamiliar styles. The brewpub connected the city to its past by opening in the same structure Joseph Knoble had brewed in long ago. And although thing changed drastically over that span of time, the Weidmans proved that Fort Smith still appreciated good beer.

Vino's Brewpub (1993–present)
923 West Seventh Street, Little Rock

There's a certain edge to downtown Little Rock. The several city blocks located between Markham Street and Interstate 630 are perhaps the most urban of Arkansas environments. High-rise buildings are found there—a real rarity for the state's skylines. In the past, crime was a problem; walking around on foot after dark wasn't always a good idea. Investment in Little Rock's downtown over the last several years has changed the city for the better. It has become a much safer place in the process. Somewhere in the space between old and new Little Rock is Vino's Brewpub.

Henry Lee is the man behind Vino's. The Louisiana native moved to Little Rock in 1989 after spending the early part of his career in the investment business in Destin, Florida. He soon grew restless and left the industry for new adventures. His timing was excellent because the savings and loan fallout happened shortly after his departure. Former clients Alan Vennes and Bill Parodi were also looking for new opportunities, so in 1990 they joined forces with Lee and started a pizza shop in downtown Little Rock. "We opened Vino's because we didn't have a place to eat good pizza and drink good beer," said Lee. He and his partners were not fans of the cracker-like crust that was prevalent in the Little Rock pizza scene in those days. Atlanta-based Fellini's sold its recipes to the new pizza entrepreneurs, and eventually came to Little Rock to show the Vino's team how to make pizza.

When Vino's first opened, it occupied just half the building it now calls home. And since the Arkansas legislature didn't legalize brewpubs until a year later, beer was not yet on the menu. Beer was, however, always in the back of Lee's mind. Although he grew up with Falstaff and Schlitz back home in Morgan City, Louisiana, he was introduced to more upscale beers like Heineken and St. Pauli Girl while attending classes at Louisiana Tech University in Ruston. When he opened Vino's, he made a point to

offer more flavorful beers, including Guinness, Bass and Harp. It was at the time one of the only places in the state that served imports on draft.

The first few years in business were rough for the new partners. "It was everything we could do to keep it going," said Lee, who eventually bought out Vennes and Parodi and took full ownership of Vino's. Lee lived and breathed pizza, eating it for most meals and spending nearly every waking moment at the restaurant. Generating cash flow was a primary concern in the early days, so Lee brainstormed ways to draw crowds. Before Vino's, the building was home to a club called DMZ, which provided a safe haven for Little Rock's punk and metal rockers of the '80s. Lee decided to tap into that history and offer a space for all-age rock shows. Vino's quickly became known as a top music venue in the capital city, with several big-name bands playing there just before hitting it big. Green Day graced the stage in August 1991, and Queens of the Stone Age played there nearly a decade later. Several great shows took place in the years between.

Henry Lee opened Vino's Brewpub because he couldn't get good pizza or beer in Little Rock at the time. *Steve Spencer.*

By 1993, Lee was seriously considering brewing beer at Vino's. He enlisted his good friend and local homebrewer Mark Crossley to help him get started on the project. The first piece of equipment purchased was a thirty-gallon kettle picked up at auction from Cummins Unit (an Arkansas state prison) in nearby Lee County. Lee didn't know much about brewing back then, but he was doing his homework and reading as much as he could. He made a few trips over to Memphis to see what Chuck Skypeck was doing at Bosco's Restaurant & Brewing Company. Lee said Skypeck provided tremendous support in the early days of Vino's. However, brewing at Vino's presented unique challenges that were difficult to overcome. There was no temperature control in the room above the kitchen, which was used for brewing. It was freezing in the winter up there and insanely hot in the summer. A 120-quart ice chest served as the mash tun, and wort was fermented in fifty-gallon trashcans. The pizza ovens vented into the

space, which wreaked havoc on fermentation. "We found out really quick that pizza yeast eats up beer yeast in a heartbeat," said Lee.

Lee soon bought the other half of the building and installed a more sophisticated brewhouse. The flooring was fortified with four inches of concrete, and the plumbing was replaced. The brewhouse—which was manufactured by Canada's DME Brewing Solutions—was intended for another brewpub, but Lee picked it up when it went unclaimed (the 3.5-barrel system is still the brewing centerpiece at Vino's). Lee then hired Michael Scheimann as brewer. He was only there for a short time, however, soon taking a job at Tabernash Brewing Company in Denver. Dave Raymond was the brewer at Vino's in the late 1990s. He brewed at Bosque Brewing Company in Waco, Texas, before arriving in Little Rock. During his time at Vino's, Six Bridges Cream Ale was popular, as was Firehouse Pale Ale. Raymond told *Brew Your Own* magazine that brewing on a small system was fun because he could experiment more than he had in the past.

A real turning point occurred when Bill Riffle was hired as head brewer in January 2001. Riffle was previously the assistant brewer at River Rock Brewing Company, also in Little Rock. Under his watch, Vino's earned a bronze medal at the 2006 Great American Beer Festival for Rock Hopera Imperial IPA and later a gold at the 2008 GABF for the same beer. "We're real proud of that," said Lee. "It's hard to win a medal when there are 600 or more breweries competing. Just making it into the finals is a huge accomplishment." Riffle was also proud: "The first one was pretty awesome. I knew I was making good beer, but really didn't expect to win a medal." He left Vino's almost ten years to the day he started in order to build his own brewery closer to his home in Mountain View, Arkansas.

Vino's went through a rough patch after Riffle's departure. Lee couldn't find the right brewer for a while, and the quality of the beer was hit and miss. That all changed when Josiah Moody became brewer in November 2011. Moody, a former medical student and a brewing hobbyist of five years, brought a more experimental approach to Vino's. He played around with farmhouse styles and used locally grown hops. "He's an excellent brewer and a really good guy," said Lee. "He's really conscientious and very smart." Moody left Vino's in 2014 to start his own beer label called Moody Brews. He employed the "gypsy" method of beer production by brewing at Choc Brewing Company in Krebs, Oklahoma. Moody briefly returned to Vino's and handled the brewing duties before taking the reins at a brewery in Bentonville, Arkansas. During his second stint, he brewed Scorpion Pepper Milk Stout, Chocolate Habanero Milk Stout and Café Romano (among others).

A significant portion of Lee's legacy revolves around the work he did to change attitudes and laws in the state regarding beer. He worked tirelessly to educate legislators on the important topics affecting brewers. He received an extraordinary amount of assistance from then state senator Vic Snyder. Snyder was an old-school southern Democrat and former family physician who frequented Vino's with his wife, Betsy. Over time, he built a friendly relationship with Lee, even though Lee didn't at first realize who Snyder was. "He'd come in all the time and we'd talk," said Lee. "One day I'm sitting there with someone else who sees Vic walk in. He stands up and says, 'Hello, Senator.' Well, I had no idea Vic was a politician!" Snyder eventually took Lee under his wing and taught him important lessons on building coalitions and getting things done in politics. The unlikely pair made a significant impact on the state's brewing industry in the process.

Looking back, Lee is particularly proud of changing local attitudes about Sunday sales. "Being able to sell our beer to-go on Sundays and proving that we weren't a danger to the existing market was important," he said. "The world wasn't going to come to an end if brewpubs were able to sell beer on Sundays." The change was good for business, of course. Sundays went from Lee's worst day of the week to his second-best day based on increased growler sales alone. "We were the only game in town on Sundays," he said. "We were selling a tremendous amount of growlers."

In 2012, Lee opened a second Vino's location in Jonesboro, a midsize college town in northeast Arkansas. Vino's 305 was open for about a year and a half, but Lee thinks that the downtown location was too much to overcome. Most of the growth in Jonesboro was pushing out to the city limits, leaving fewer potential customers in the vicinity of the restaurant. Lee broadened the menu out from pizza and calzones and had twenty-four beers on tap with a full bar, but ultimately sales just weren't strong enough to maintain operations and Vino's 305 closed.

Vino's is a downtown institution in Little Rock. It's the city's longest-running brewery and has served as home base for punk rockers and business people alike for nearly thirty years. Long lines form at the front counter during the lunch hour. The after-work crowd is just as dense. There's an edge to Vino's, just as there's an edge to the gritty neighborhoods that surround it. The punk rock ethos lives on inside the brewpub, which shows wear and tear from the many shows that have happened there through the years. Lee is proud of what he has accomplished but is finding time to relax more these days. With a number of new breweries in the state, he has allowed others to pick up the legislative work that is still so important

to the state's brewers. Now he spends as much time outdoors as possible. Lee has a place on the Little Red River, about an hour away from Little Rock. Ever the outdoorsman, the Louisiana native appreciates a little sunshine on his shoulders. "I can walk off the dock and wade out there on a nice little shoal and catch rainbows and browns."

OZARK BREWING COMPANY (1994–2004)
Fayetteville

Northwest Arkansas was one of two major population centers in Arkansas, but until 1994, it did not have a brewery of its own. That changed when John Gilliam opened Ozark Brewing Company in downtown Fayetteville. Suddenly, homebrewers and hopheads had a place to hang out and talk about styles other than pilsner.

Gilliam grew up between New York, Chicago and Cleveland and was a self-described "flaming yankee." Most of his beer knowledge was gained from being a beer consumer. Then, in 1989, he decided to take a course in brewing at Siebel Institute of Technology in Chicago. "While I was there going to school I ended up getting a job with them as a salesman," he said. His task was to sell transfer hoses to breweries. He later went through the full brewing program and built a deeper understanding of the commercial brewing process. He read as many books as possible from the Brewers Association, the industry's trade organization. Hands-on learning in the classroom coupled with his own extracurricular studying helped Gilliam get an idea of what styles and recipes best fit his personality. He also took advantage of the small brewery in the school's basement. On Saturdays, his children tagged along as he experimented with recipes and ingredients. He put them in lab coats as he brewed batch after batch. There in the Siebel basement, he started to get a feel for different malts and hops available to brewers. He also determined which recipes he would hang on to if he ever opened a brewery of his own.

Gilliam's stepmother, Maggie Gilliam, encouraged him to pursue his brewing aspirations. She was a retail analyst on Wall Street and followed Bentonville, Arkansas's Walmart closely. She visited the company's corporate headquarters and saw that there was potential in the growing region. When she suggested to her stepson that they take a look at Fayetteville—a college town about twenty miles south of Bentonville—

to locate his brewery, his first thought was, "Excuse me?" It took John Gilliam about a year to finally board a plane and visit Fayetteville for himself. When he arrived, however, he knew that he had found the right place. His young family was important to him, and he was looking for a city more suitable than Chicago to raise children. "If you have kids Fayetteville is a dynamite place," he said. "The schools are great and there's virtually no crime." Another factor influencing his decision was the University of Arkansas. Students and professors might provide a steady clientele, he thought. John Gilliam and his stepmother, who served as his business partner and financier, looked at several properties in downtown Fayetteville before settling on a pair of decrepit buildings at the corner of Dickson Street and West Avenue.

The properties were originally built in 1880 and 1900 and contained a combined eleven thousand square feet of space. Former tenants included Bates Brothers, the University of Arkansas post office, Bill and Lil's, the Swinging Door and the Whitewater Tavern. One of the most iconic images of 1970s Fayetteville was the two-story cowboy mural on the front of the Swinging Door (a popular and somewhat rowdy tavern). The bar often played host to a band called Zorro and the Blue Footballs. Streakers were known to frequent their shows, and the combined antics of the band and the crowd often spiraled into full-on debauchery.

The condition of the buildings was in question when the Gilliams took possession. After inspecting the structures, it was obvious that a tremendous amount of work needed to be done if the brewpub would ever become a reality. "When we were in the throes of demolition, we were taking down walls that had no Portland in the cement," John Gilliam said jokingly. "It was basically God and gravity keeping those walls standing." D.A. Waters Design & Construction Inc. served as contractors on the project. Renovations took nearly two and a half years to complete. When finished, the buildings had gone through a complete transformation, top to bottom and inside out. The new brewpub contained several interesting features, such as hand-joined post-and-beam construction and Douglas fir wood floors. Vaulted ceilings and a copper roof helped the brewpub garner attention. The National Commercial Builders Council awarded Ozark Brewing Company an honorable mention in the Urban Renewal and Revitalization division out of more than two hundred entries. The renovation of a major building in Fayetteville's entertainment district quickly became a source of pride for the city's residents. Ozark Brewing Company officially opened for business on Memorial Day 1994.

John Gilliam served as the brewmaster, which was no surprise given his training. The brewing system was a ten-barrel copper brew kettle built by Vendome Copper and Brass Works Inc. in Louisville, Kentucky. Ozark's first beers included Long Rein Ale (an amber ale), an IPA, Coach Light Ale (for drinkers transitioning from industrial lagers), Six in Hand Stout, Horseshoe Hefeweizen and Freckleberry Bitter. Parker Lee IV, who graduated from the Culinary Institute of America, served as the brewpub's first executive chef. With seating for about two hundred, Ozark Brewing Company was positioned for large-scale success.

The beer was a hit from the beginning, especially with the growing homebrewing community. In May 1994, the local homebrewing club, Fayetteville Lovers of Pure Suds (FLOPS), began holding its monthly meetings at the brewpub. The club was founded around the same time Ozark opened, creating a synergistic relationship between the two that survived for many years. Competitions were hosted at the brewpub, with winners given the opportunity to brew their recipes there. The club's founder, John Griffiths, was appreciative of Ozark's support and wrote the following in the fall 2004 newsletter:

> *I was delighted to see Ozark Brewing Company open and busy. Our first club meetings at OBC have been a great success, and my thanks go to John Gilliam for providing FLOPS with a "home." John's beer are excellent—let it be on record that anyone caught drinking the "other" stuff at a FLOPS meeting will be excommunicated, hung, drawn & quartered, or all of the above!!*

Things seemed to be going gangbusters for John Gilliam. Then, in September 1998, Fayetteville voters approved Sunday alcohol sales at restaurants not classified as private clubs. Ozark took quick advantage by opening for business on Sundays. The move strengthened sales figures that were already considered strong. For many years, the brewpub was a top performer among Fayetteville restaurants. It finished 1998 with just over $1.5 million in sales.

Ozark Brewing Company was a remarkable place at its peak, serving as a cultural center point for the region. One memorable event involved the hoisting of a goalpost in front of the brewpub after the Arkansas Razorbacks defeated the Tennessee Volunteers in a 1999 football game. The victory was sweet revenge for a heartbreaking loss to the Vols by the very same score the year before in Knoxville, Tennessee. That loss had effectively knocked the

Hogs out of contention for the national title—a heartbreaking outcome for many. A horde of rowdy fans marched the goalpost out of the stadium, over a steep hill and down Dickson Street to the brewpub after the Hogs' 28–24 win in '99. Fans signed the goalpost and posed for pictures for the rest of the night.

They say that all good things eventually come to an end. This old axiom proved true when Ozark Brewing Company closed in May 2004. John Gilliam called a recently enacted smoking ban in city restaurants the "final straw" for his business. Fayetteville was only the second city in the state of Arkansas to prohibit smoking in restaurants, achieved through a 52 percent voter approval in a special referendum. The issue was highly controversial at the time but perhaps an indication of how progressive Fayetteville was as a community. Most cities in the state—and, for that matter, the entire country—would soon follow suit and ban smoking indoors. John Gilliam said that the initial loss of business, coupled with a shift in dining and entertainment toward Benton County, was enough to convince him to sell the brewpub. Kari Larson and Julie Sill, co-owners of the popular espresso bar Common Grounds (a few doors down from the brewpub on Dickson Street), purchased Ozark from the Gilliams in 2004 and rechristened it Hog Haus Brewing Company. John Gilliam stayed on as brewer for a few years to ease the transition.

Downtown Fayetteville had fallen on dark days prior to Ozark Brewing Company arriving on the scene. Stabbings were reported on Dickson Street, and many people stayed away instead of risking their safety for a night on the town. Buildings fell into disrepair, and Dickson became an eyesore in what was otherwise a thriving community. Things started to change in 1992 when the Walton Arts Center opened at the corner of West Avenue and Dickson— directly across the street from what would become Ozark two years later. Those two businesses sparked reinvestment in Dickson Street. As a matter of fact, Ozark should be credited with sparking the brewing industry in Fayetteville. Several breweries eventually followed in John Gilliam's footsteps, but Ozark Brewing Company will always be known as the first of its kind in the city.

River Rock Brewery/Chit's/Castaway Island Grille & Brewery (1997–2002)
Little Rock

River Rock Brewery opened in the revitalized Little Rock River Market in late 1997. It was one of the first businesses to open in the area after money

started pouring in to save the deteriorating downtown district. A seven-barrel copper brewhouse from DME Brewing Solutions was the domain of brewer Omar Castrellon, who had previously worked at breweries in North Carolina, Alabama and California. He signed on at River Rock in June 1997 and quickly made a name for himself with quality beers such as Crossroads Cream, Pig Trail Ale and Flathead Stout.

Castrellon hired Bill Riffle as his assistant brewer in 1999. That same year, the original owners of River Rock—Tom Stanton, Bobby Whitfield and S. Porter Brownlee—had a falling out with restaurant manager Carlton McCrary, who was originally given a 5 percent interest in the business for joining the team. Due to a mixup with River Rock's articles of organization, which were filed with the secretary of state, McCrary was inadvertently listed as having authority over the business. Upset with his firing, he refused to relinquish control despite only having a small stake in River Rock. A lawsuit was filed to settle the dispute, and an injunction was granted so that the majority owners could renew their brewing permit (which was at one point in serious jeopardy).

River Rock's troubles continued as the brewpub fell behind in paying city sales tax. The brewpub closed for a short time in 2000 and reopened under the name Chit's. A southwestern menu was introduced to spice things up, but the brewing duties were still handled by Castrellon. He proved to be the only constant in an ever-changing restaurant environment. Despite the turmoil, he continued to brew excellent beer. Chit's Lager was popular with locals, as was White River Wheat, the brewpub's only unfiltered beer.

The ambience of Chit's didn't go over well in Little Rock, so ownership decided to revamp the restaurant's theme one more time. They introduced Castaway Island Grille & Brewery in May 2001. Enchiladas were replaced with jerk chicken, and palm tree décor was scattered throughout the massive dining room to liven things up. Fortunately for the city's beer drinkers, Castrellon remained as brewer. He made some splendid beers during the restaurant's third iteration, such as Castaway Ale (a honey-conditioned cream ale), Castaway St. Thomas Brown and Island Pale Ale. Despite the consistency of the beer, management couldn't seem to turn the corner on the food side of the business. Castaway closed in January 2002, a mere eight months after changing formats and a short four years (and a few months) after originally opening as River Rock Brewery.

Castrellon made excellent beers and became a well-regarded brewer in Little Rock in a relatively short period of time. He kept his brewing relatively straightforward because the city was just starting to appreciate flavorful beer.

There wasn't much of an appetite for experimental beers—sour beer and barrel aging was still a long ways away. The business certainly didn't fail due to the beer, however. River Rock/Chit's/Castaway's problems were mostly a results of the ownership team's internal conflict—and perhaps because the River Market was still in its infancy. Safety was somewhat of a concern at the time, and downtown parking was such a headache that many people simply didn't make the effort to go there.

Castrellon stayed in Little Rock for a few months after Castaway closed. He was slated to become the brewer at Bosco's—which moved into the space formerly occupied by Castaway—but it took a little longer than anticipated for the Memphis-based brewpub chain to open. So Castrellon moved on to Indianapolis, Indiana, and helped open what would become a highly successful brewery known as Thr3e Wise Men. Fortunately for Arkansas beer drinkers, Castrellon returned to Little Rock to brew again several years later.

LAYING THE GROUNDWORK

Brewing beer in Arkansas after Prohibition was not an easy thing to do. Although Jimmy Carter signed a bill in 1978 that made homebrewing legal on a federal level, it was several more years before Arkansas legislators followed suit. Brewpubs were not allowed in the state until 1991, and production brewers were hamstrung by the requirement to distribute their beer through a wholesaler. In a distribution environment that favored the big national brands, developing sales to the point of sustaining an Arkansas-based brewery was nearly impossible. Fortunately, there was a sizeable contingent of homebrewers in the state who enjoyed making their own beer (even before it was legal). Eventually, legislators realized the economic benefits of making commercial brewing legal, and relaxed the regulations that had long hampered the industry.

Homebrewers

Arkansans have brewed their own beer for many decades, even though the practice wasn't technically legal in the state until Senate Bill 636 was signed into law in April 1995. It amended several earlier state codes to allow anyone over twenty-one years of age to brew one hundred gallons of beer per year, or up to two hundred gallons if two or more adults lived in a household. A full two years before it was signed—on April 4, 1993—

Members of FLOPS gear up for Big Brew Day. *Fayetteville Lovers of Pure Suds.*

a group of Northwest Arkansas homebrewers formed a club called the Fayetteville Lovers of Pure Suds.

More commonly known as FLOPS, the club was founded by Dr. John Griffiths, who was then a professor in the University of Arkansas's geology department. Griffiths was a Welshman by birth and had spent time in both Australia and Canada before arriving in Fayetteville. He homebrewed for many years prior to meeting other like-minded hobbyists and forming FLOPS. He explained the reason for the club in a 1993 newsletter:

> *Who are we? Fayetteville Lovers of Pure Suds—a small group of home brewers of beer in Northwest Arkansas who enjoy making and drinking home-brewed beers. Yes, we drink commercial beers too, but enjoy the wonderful ales and lagers that can be made from basic ingredients, in the tradition of times that had almost vanished until the revival of the "real-ale" movement in Britain and the United States some fifteen years ago.*

Griffiths was intent on creating an educational environment for members. Sharing best practices was encouraged, as was entering competitions and getting feedback on the beer. The club visited area breweries, such as Weidman's Old Fort Brew Pub in Fort Smith, Arkansas. In fact, FLOPS was notorious for having a good time, and many members had a keen sense of humor. Stephen C. Rudko, who was the club's "Minister of the First Year Plan," wrote in the first newsletter:

> *The season of brewing, having for so long been but a seductive glimmer on our collective horizon (as a coquettish mistress in the fine mists of memory; ethereal, sensual, illusory), has now overtaken, nay—overwhelmed and overpowered us in on mighty, Panzer-like, steamrolling juggernaut! Comrades to your pots and stoves, to your colanders, to your most holy vessels of fermentation! Gird your accouterments, your hoses and thermometers!*

Laying the Groundwork

The days of our blissful labors, the months for jubilant toiling have suddenly begun! Turn each among you to the other and animate, encourage and illuminate all! For this is our cry: All must brew! All must celebrate with hearts and minds linked, as we dance purposefully, hedonistically to the frenzied bubbling of our own air-locks!

A year after FLOPS was formed, Ozark Brewing Company opened on Dickson Street in downtown Fayetteville. Club meetings were hosted there, and sometimes winners of club competitions were invited to brew on the brewpub's system. Griffiths, who won numerous local, regional and national competitions, once brewed Dr. John's Magic Stout at Ozark. Also an accomplished writer, Griffiths wrote numerous articles for *Zymurgy* magazine, including a detailed piece on single-infusion mashing.

Griffiths died in July 2005, but his legacy lives on with FLOPS, which continues to meet on the third Thursday of each month. Many professional brewers in Northwest Arkansas attended meetings prior to starting their own breweries. In some regards, the groundwork for the beer industry in that corner of the state was laid when FLOPS formed in 1993.

The Home Brewery, owned by club member Andy Sparks, intermittently provided the club with space to meet through the years, and naturally, the raw materials for brew days were purchased there. Sparks's legacy is intertwined with FLOPS, and it would be a serious omission if he weren't mentioned in this text.

Homebrewers had a unifying presence in other Arkansas cities as well. Fort Smith's Hell on the Border Homebrew Club was active in the early '90s. It operated for several years before being supplanted by the River Valley Ale Raisers. The Ale Raisers are still operating in Fort Smith and, in fact, sponsor one of the region's largest homebrewing competitions: the All-American Brew Off. The club also hosts a beer festival called Ale on the

The Home Brewery was the site of many meetings of the Fayetteville Lovers of Pure Suds (FLOPS). *From the* Fayetteville Flyer.

The Central Arkansas Fermenters is a Little Rock homebrewing club that has produced several professional brewers. *Central Arkansas Fermenters.*

Border. Proceeds from Ale on the Border are donated to Antioch Youth & Family, which provides food assistance to more than seven thousand people in the Fort Smith area.

Down in Little Rock, the Central Arkansas Fermenters club was founded in 2003. The club's website explains its purpose:

> *The mission of CAF is to provide education and enhance the awareness and understanding of the art, science, and craft underlying the at-home brewing of beer, ciders, wines, and other fermented beverages throughout the Central Arkansas region, and to use that craft to benefit other charitable organizations in the area.*

The Central Arkansas Fermenters hosts the annual Little Rocktoberfest each year in September. The festival is one of the biggest beer events in the state and features homebrew, home state breweries and non-Arkansas craft beer provided by distributors. Each year, the club selects a charitable organization to receive a portion of the festival proceeds. Like the clubs in Fayetteville and Fort Smith, the Central Arkansas Fermenters meet regularly and host beer competitions throughout the year. Several current Little Rock brewers, including the owners of Stone's Throw Brewing, have been club members in the past.

Although Fayetteville, Fort Smith and Little Rock have the longest-running clubs in the state, there are several others that have emerged over the past few years. The American Homebrewers Association lists several, including the Ozark Zymurgists (Bentonville), Hot Springs Homebrewers, Jonesboro Area Brewers, Arkansas Hillbilly Homebrew Club (Oppelo) and Brewers of Zymurgical Offerings Society (Russellville).

Laying the Groundwork

Legislative Changes

It can't be emphasized enough: brewing laws in Arkansas were considered restrictive for most of the state's history. Forced participation in the three-tier distribution system stymied several early attempts to start breweries, and the extremely low limit on brewing output made profitability an elusive goal.

As already discussed, the first real attempt at commercial brewing in Arkansas following Prohibition was Arkansas Brewing Company, which operated from 1984 to 1986. Distributors were, at the time, supremely loyal to their benefactors in industrial brewing towns like Milwaukee and St. Louis. It was extremely hard for Arkansas Brewing Company to find a distributor willing to carry its beer. And on top of that, beer output was by law capped at only 1,500 barrels per year. These factors were hardly a recipe for success for a small startup brewery. Arkansas Brewing Company folded amid a difficult brewing environment in Arkansas. Things had to change if the industry was going to find any measurable success in the state.

Things did start to change in 1991 when Arkansas legislators passed a law that allowed brewpubs to operate inside the state for the first time in modern history. Act 611 authorized the establishment of "microbrewery-restaurants" as a limited exception to the three-tier system of beer distribution. The act allowed brewpubs to produce up to 1,500 barrels of beer each year, with all of it to be sold for on-premises consumption. The law helped usher in a new era for the Arkansas brewing industry. Selling beer directly to consumers helped breweries avoid the pitfalls associated with distributors. Weidman's Old Fort Brew Pub opened in Fort Smith a year after the law was enacted, becoming the state's first.

In 1993, Vino's—which was already in the business of making pizza—started brewing beer in Little Rock. Fayetteville got its own brewpub in 1994 when Ozark Brewing Company opened. Once seen as a novelty found exclusively on the East and West Coasts or in places like Colorado, brewpubs were all of a sudden legitimate moneymaking enterprises in Arkansas. The first three brewpubs in the state enjoyed wonderful success and, in the process, helped pave the way for the next phase of the Arkansas brewing industry.

Vino's owner Henry Lee played a major role in changing the state's brewing laws. He began working with then state senator Vic Snyder in 1993 to make updates to what many considered to be outdated rules on brewing. "For five straight legislative sessions I was up at the capitol, meeting with people and talking to folks," said Lee. "The first thing I wanted to get done

was to allow brewpubs to sell beer to people to take home." Many people now take growler sales for granted, but there was a time when they were simply not allowed. That changed in 1995, when the Arkansas legislature passed Act 491. It allowed brewpubs to sell brewery-sealed packages for off-premises consumption. The act also provided for the sale of beer to charitable organizations and increased the maximum brewing output at brewpubs to five thousand barrels. These changes were seen as important victories for the state's brewers.

Despite these wins at the state capitol, production-only brewers were still limited in their ability to reach the market. Michael Langley, director of the state's Alcoholic Beverage Control agency from 2007 to 2015, said that the state's distributors were a powerful lobby and had a firm grip on the market through the 1990s. "The law was prohibitive in terms of getting your product out," he said. "You couldn't make it and serve it at the same location [referring to taprooms]."

The handful of brewers operating in the state realized how important it was to pool their resources if change was ever to happen. "Back then the climate was very poor for small local breweries," said Russ Melton of Diamond Bear Brewing Company "There were five of us—Diamond Bear, Vino's, Bosco's, Ozark Brewing Company, and West Mountain [which wasn't actually brewing at the time]. We formed as a guild and hired a lobbyist to help make some changes." Thus, the Arkansas Brewers Guild was established in 2003. A united voice amplified the cry for change in the state's brewing laws. "We gained a lot of legislative support as a result," said Melton.

The same year the guild formed, the Arkansas Native Brewery Act was passed into law. It was perhaps the single most important legislation in the history of the state's beer industry. The law allowed Arkansas brewers to self-distribute their beer to retail accounts. This dramatic shift enabled them to overcome the biggest barrier to market entry: the three-tier system. The law also allowed for taproom sales and pushed the production limit for small breweries to sixty thousand barrels per year. These changes represented an important shift in how beer production was viewed inside the state and provided the catalyst for unprecedented industry growth in the years that followed.

The Arkansas Brewers Guild was a driving force behind the law and continues to advocate on behalf of the state's beer industry. "One of the most important things is for all of us to stay united," said Melton. "We need to agree on the key items that can move our industry forward and set a

Laying the Groundwork

Arkansas Brewers Guild secretary Evan McDonald meets with Senator John Boozman. *Apple Blossom Brewing Company.*

very good example. The image of our state is important to all of us." In recent years, the guild has increased its scope to include issues that affect the national beer industry, not just the state's. Guild secretary Evan McDonald, co-owner of Apple Blossom Brewing Company in Fayetteville, traveled to Washington, D.C., in 2015 to talk to legislators about the impact of two competing pieces of legislation that sought to recalibrate the federal excise tax on beer. Back home in Arkansas, the guild frequently hosts tap takeovers and other events to raise funds for its work.

In the years that followed the Arkansas Native Brewery Act, the state saw several more changes to laws affecting brewers. In 2007, state excise taxes were removed from the first twenty-five thousand barrels produced by a brewery. This economic incentive further encouraged brewers to enter the market or, if already operating, to expand their production capabilities. In 2009, beer licenses were further clarified (the term "small brewer" was introduced), and it became legal to sell beer on Sundays for both on- and off-premises consumption at small breweries. And much to the delight of Arkansas beer drinkers, growler sales at stores with retail beer permits were legalized in 2014. The following year, maximum brewpub output was pushed to twenty thousand barrels. Change was fast and furious and, in almost every instance, highly beneficial to the industry.

Today, Arkansas is considered friendly to beer producers compared to many nearby states. The American South has deservedly earned a reputation as being restrictive toward brewers, but probably for reasons other than what most people think. The prevailing thought is that religion is the root cause for the region's trailing interest in locally produced beer. That's not necessarily the case, according to former ABC director Langley. "It is not about morality," he said. "It's all about the wholesalers. In truth, morality does not play a part in the decision making of how alcohol law is imposed. It's the excuse, but it's not the reason. The reason is money." Fortunately for the citizens of Arkansas, state lawmakers began realizing in the 1990s that brewing beer could mean a windfall for the state. The economic impact of

The Arkansas Brewers Guild promotes the economic benefits of a strong brewing industry in the state. *Brian Sorensen.*

more brewing freedom (valued at $324 million for the state of Arkansas in 2015, according to the Brewers Association) was worth more than pandering to the out-of-state industrial brewers and the handful of local distributors that had a longstanding stranglehold on the Arkansas beer market.

Despite the progress, there is still more work to be done. The state remains a collection of wet and dry counties, with local regulations that prevent prospective brewers from pursuing their dreams. Langley said that he would like to see places like Jonesboro and Conway—which are growing quickly but located in dry counties—able to take advantage of the growth in local brewing. "If you can make Jack Daniels in a dry county in Tennessee, you ought to be able to make beer in a dry county in Arkansas."

DIAMOND BEAR BREWING COMPANY

Brewpubs were having some success in Arkansas in the 1990s. Packaged beer, however, had yet to make a full return to the state after Little Rock Brewing & Ice Company stopped bottling beer in 1915. Arkansas Beer Company gave it a go in the '80s, and Weidman's converted from brewpub to full-scale brewery in the late '90s. But neither was able to gain any momentum, and they both closed after just a short time in operation. Arkansas was still awash in mass-marketed lagers, and the state seemed five to ten years behind beer industries in bigger states. That all changed when a tire salesman returned to his home state.

Russ Melton was born and raised in Malvern, Arkansas. In those days, Malvern was a prototypical small southern town, located about forty-five miles south of Little Rock on Interstate 30. For many years, its claim to fame was being hometown to three Acme brick plants, and it was often referred to as the "Brick Capital of the World." Many people simply knew it as the closest town to resort town Hot Springs, with its fancy bathhouses, illegal gambling and vacationing movie stars. Malvern knew none of those things, providing a much slower pace of life, which suited the Melton family just fine.

As a boy, Melton was taught by his parents to have a strong work ethic. His father was a hardworking manufacturing supervisor, and his mother was a professional educator. After high school, Melton attended college in nearby Arkadelphia, where he studied business management and military science at Henderson State University. Melton's mother was a math

professor at the school. He took her class once, only to earn a final grade of 89.7 percent. Always a stickler for hard work and a well-taught lesson, she declined to round him up to A. It reinforced the idea that Melton would always have to work hard for what he wanted.

After college, Melton joined the United States Army. From 1979 to 1983, he was stationed in Schweinfurt, Germany, with the Third Infantry Division. "Schweinfurt was a town the size of Hot Springs, or just a little bigger, with three breweries," he said. "The beer was always good there." Melton served as a tank officer while in Germany and fondly remembers drinking the local beer at Brahaus Brewing Company during his time there. While on leave, he traveled to neighboring countries such as Belgium and Austria and sampled beer styles different from those near base. Melton credited his military service for introducing him to flavorful beer.

After returning from Europe, Melton started a career in sales and marketing for Michelin Tire Company. He moved up the corporate ladder swiftly, relocating around the country several times while taking jobs with more responsibility. Over his thirty-one-year career at Michelin, he lived in Jonesboro, Arkansas; Dallas; Kansas City; and eventually Little Rock.

Melton was in Kansas City just as Boulevard Brewing Company was beginning to make its name in the Midwest. John McDonald opened Boulevard in 1989 and quickly established the brewery as a regional player. Growth came quickly and Melton took notice. He toured Boulevard in 1993 and, seeing the brewing operation for himself, started to think about doing the same thing back home in Arkansas.

In 1994, Melton moved again with Michelin, this time to Little Rock. He was recently divorced, and the move put him closer to his sons, all of whom lived in the city. After so many years on the road—including overseas military service and several corporate relocations—Melton was back in his home state again. From the sideline he continued to watch the beer industry grow. He thought often of building a brewery of his own. The nationwide trend toward locally produced beer was on the upswing, and he thought that it could work in Arkansas, too. So he got serious about the idea and started working on a business plan in 1997.

Once the business plan was complete, he began looking for financing partners. It was obvious from the beginning, however, that Arkansas was full of skeptics. "I had really done my homework," said Melton. "I had a pretty strong business plan. I told one of the bankers that Arkansas didn't have any production breweries of our own. I remember him kicking back in his chair and saying, 'It's Arkansas—they're not going to buy that stuff.'" It was typical

DIAMOND BEAR BREWING COMPANY

Russ Melton is an Arkansas native and the founder of the first successful production brewery in the state since Prohibition. *Diamond Bear Brewing Company.*

thinking in those days. The state's two brewpubs—Vino's and Ozark Brewing Company—were doing well for themselves, but in many people's minds, they were passing fads destined to fail. The majority of beer drinkers, particularly in Arkansas and the rest of the American South, maintained a strong preference for the lagers made by Anheuser-Busch, Coors and Miller (and the like). "I remember being even more determined after that," said Melton, remembering his conversation with the skeptical banker. Melton, his new wife, Susan, and a few family members pooled their resources and launched Diamond Bear Brewing Company without assistance from the banks.

Starting a business on a shoestring budget influenced many of the early decisions, including where to locate the brewery. Melton saw a few places that really appealed to him, but he didn't think he could maintain high payments on those particular properties. 323 Cross Street in downtown Little Rock proved to be the right location at the right price. The seven-thousand-square-foot building was the former home of a Lincoln Motor dealership and was just a few blocks from the Arkansas capitol building. It was an appropriate place for Melton to start what he hoped would become the state's flagship brewery.

Having a place to call home was just part of the equation. Melton quickly launched a search for a brewer. He never really considered handling the

Diamond Bear Brewing Company was originally located in a former Lincoln dealership at 323 Cross Street in Little Rock. *Diamond Bear Brewing Company.*

brewing duties himself. He had homebrewed a few times in his life but didn't want to wager a new business venture on his limited brewing experience. "An English bitter was the best one I ever made," he said. The rest of his brews he considered pedestrian. So finding someone he could trust with brewing duties was important. The search proved difficult because the talent pool was relatively shallow back then. There just weren't many small breweries in operation, and therefore, there weren't many brewers available for hire. "It wasn't like going out and getting a restaurant manager," said Melton. "I interviewed several brewers and eventually hired John Templet from out on the West Coast." Templet had spent the previous eight years at Mendocino Brewing Company in Hopland, California. Toward the end of his time there, he was in charge of the brewhouse. Those were the kinds of qualifications Melton was looking for. Everything seemed to be falling into place.

Diamond Bear brewed on its fifteen-barrel brewhouse for the first time in September 2000. The first keg was tapped a month later at the Flying Saucer in downtown Little Rock. Pretty soon, Diamond Bear

was showing up in bars and restaurants all around town. Beer drinkers responded enthusiastically to the product and to the brewery's brand (which invoked a couple past state nicknames—the Diamond State and the Bear State). At first, Diamond Bear only produced beer for draft accounts. With very few bottling lines available in the United States at the time, bottling appeared to be a costly proposition. Then a friend at Saint Louis Brewery (which produces beer under the Schlafly brand) recommended that Melton look into contract brewing. Increasingly, breweries with excess capacity were willing to brew other people's beer for a fee. It appeared to be a more cost-effective way for Melton to start packaging, and in early 2002, he chose Gluek Brewing Company in Cold Spring, Minnesota, to bottle for Diamond Bear. Beer destined for draft accounts was still brewed back home in Little Rock.

The inconsistency of the beer produced in Arkansas was beginning to frustrate Melton. Sanitation was an ongoing issue, and several batches of beer were destroyed due to infections and other off-flavors. "Those issues really hurt us financially," said Melton. He brought in brewing consultants to help diagnose the problem, but they could never solve it completely. Sensing that his business was at a crossroads, Melton made the difficult decision to change brewers and posted the open position for hire. Charles Kling, a brewer at Abita Brewing Company in Louisiana, saw the advertisement and decided to apply. In 2002, the classically trained Kling (he held a certificate of brewing science from the American Brewer's Guild) was hired as Diamond Bear's head brewer. Right away, he demonstrated a knack for solving the brewery's quality control problems. To this day, Melton believes that hiring Kling was one of the keys to turning things around.

Improving conditions led to distribution deals in Tennessee and Louisiana for Diamond Bear. Brewing output was clearly on the upswing, and things seemed to be going well for Diamond Bear. Despite the success, Melton was still bothered by inconsistent flavor profiles. Consumers often told him that the draft and bottled version of his beers—which at the time included Southern Blonde and an English-style pale ale—tasted different from each other. Melton attributed the variation to the water sources for each version of the beer. He thought that Lake Winona, the source for his Arkansas-produced draft beer, was far superior in quality to what was used in Minnesota. Melton decided it was time to bring the bottling operation home to Arkansas to create consistency. So, in 2003, he purchased a Meyer 40-10 bottling line from a company in Green Bay, Wisconsin. It was affectionately named "Helga" in keeping with the tradition of naming

the vessels in the brewhouse. "We brought Helga in and it was a drastic improvement in the quality of the product," he said. Volunteers, known as "Helga's Helpers," handled bottling duties and were rewarded with a case of beer at the end of each shift.

Diamond Bear gained momentum after the bottling operation moved south. The brewery competed at the Great American Beer Festival and earned a silver medal out of thirty-two entries in the classic English-style pale ale category. "When you get to that level it's so competitive and everyone is so good," said Melton. "It's a roll of the dice whether you get a medal or not." Diamond Bear followed up the 2003 medal with a gold in 2005 (Irish Red) and a gold (Pale Ale) and bronze (Honey Weiss) in 2007. The World Beer Cup—another prestigious beer competition—resulted in gold (Pale Ale) and bronze (Irish Red) in 2004 and a gold medal (Pale Ale) in 2006. The hard work was beginning to pay off for Melton and the rest of the Diamond Bear team.

Kling eventually married and moved to West Virginia to complete his engineering degree. Fortunately for Melton, there was a succession plan in place. His son Jesse trained under Kling and was prepared to take over the head brewing duties. Jesse Melton is not the only family member involved in the business. Russ Melton's other sons, John and Scott, also work at the brewery, as does his wife, Susan. Diamond Bear is most certainly a family affair.

The transition of brewers went well, and Diamond Bear didn't miss a beat. The days were numbered at 323 Cross Street, however, as distribution growth was suddenly dependent on adding more capacity. Diamond Bear had already hit its brewhouse limit of three thousand barrels and was feeling the squeeze. Melton began looking for a bigger location to move the brewery, and at one point, he signed a contract for a property in Little Rock. The owner of the property ultimately backed out of the deal. It was a setback for Melton and his team after they spent more than a year negotiating and planning for that particular location. A follow-up search yielded the former Orbea bicycle distribution facility at 600 North Broadway Street in North Little Rock. According to a report from *Arkansas Business*, Diamond Bear paid $820,000 for the fifteen-thousand-square-foot building and the accompanying three acres. "It started as a Continental Trailways bus terminal and service facility," Melton said about the property. "They'd bring the buses in here and they'd service and wash them. In the brewing area there's a bay with a stainless steel lift still buried under the concrete." The new locale put Diamond Bear in the same vicinity as Dickey-Stephens

Left: The logos for Columbus House Brewery & Taproom's year-round beers are colorfully designed. *Columbus House Brewery & Taproom.*

Below: Saddlebock Brewery started canning its beer in October 2015. *Brian Sorensen.*

Stone's Throw Brewing is located in Little Rock's historic MacArthur Park neighborhood. *Stone's Throw Brewing.*

Cans of Lost Forty beer can be found throughout the state. *Little Rock Convention & Visitors Bureau.*

Johnny Two-Pints serves as the logo for Rebel Kettle Brewing Company. *Rebel Kettle Brewing Company.*

Bike Rack Brewing Company moved to its new home in the 8th Street Market in May 2017. *Brian Sorensen.*

Superior Bathhouse Brewery serves a variety of beers along with those brewed onsite. *Arkansas Department of Parks and Tourism.*

The River Valley Ale Raisers sponsor several beer events in the Fort Smith area. *River Valley Ale Raisers.*

Co-owner Alan Tackett serves 501 Brewing Company beer at Little Rocktoberfest. *501 Brewing Company.*

Friends celebrate good beer at Frost Fest 2016 in Fayetteville. *Brian Sorensen.*

Apple Blossom Brewing Company places an emphasis on food. *Arkansas Department of Parks and Tourism.*

Co-owner Ian Beard poses outside Stone's Throw Brewing. The brewery opened in 2013. *Stone's Throw Brewing.*

The Fayetteville Visitors Bureau launched the Fayetteville Ale Trail in 2013. *Arkansas Department of Parks and Tourism.*

Lost Forty Brewing Company is one of the biggest beer producers in the state. *Arkansas Department of Parks and Tourism.*

Above: New Province Brewing Company offers several year-round and rotating beers in its taproom. *Brian Sorensen.*

Left: Long communal tables make Lost Forty Brewing Company a popular place to meet friends for dinner and beer. *Arkansas Department of Parks and Tourism.*

Left: Josh Quattlebaum brewed at Bosco's before making the transition to Damgoode Brews. *Scott Parton.*

Below: Hog Haus Brewing Company's beers are brewed on contract at Saddlebock Brewery in Springdale. *Brian Sorensen.*

Jefferson Baldwin and Andy Coates from Ozark Beer Company serve at the 2014 St. Patrick's Day on the Hill beer festival in Fayetteville. *From the* Fayetteville Flyer.

Ian Beard from Stone's Throw Brewing serves at the 2014 St. Patrick's Day on the Hill beer festival in Fayetteville. *From the* Fayetteville Flyer.

Will Gallaspy, former brewer at West Mountain Brewing Company, prepares to start the boil. *From the* Fayetteville Flyer.

A pint of beer from Bentonville Brewing Company. *Michael McAllister.*

Fayetteville anchors one of the fastest-growing regions in the United States. It has a vibrant downtown nightlife. *Arkansas Department of Parks and Tourism.*

Whitaker Point in the Buffalo River Valley is one of many geological wonders in the state. *Arkansas Department of Parks and Tourism.*

Arkansas Brewing Company operated from 1984 to 1986. Popular beers included White Tail Beer, Riley's Red Lyon and Ten Point Beer. *Kevin Keeton.*

Blue Canoe Brewing Company pays homage to brewer Laura Berryhill's love of the outdoors. *Blue Canoe Brewing Company.*

Vino's Brewpub opened in 1993 at the corner of Chester and Seventh Streets in downtown Little Rock. *Little Rock Convention & Visitors Bureau.*

Owner J.T. Wampler pours a pint at Tanglewood Branch Brewing Company. Tanglewood closed in September 2014. *From the* Fayetteville Flyer.

Springdale's Core Brewing Company has opened numerous pubs across the state. *Brian Sorensen.*

Core Brewing & Distilling Company expanded in 2016 with the addition of three 160-barrel fermenters outside the brewery. *Brian Sorensen.*

Four of the six owners of Apple Blossom Brewing Company pose in front of the brewery window. *Brian Sorensen.*

Basic Brewing Radio host James Spencer films Apple Blossom Brewing Company brewer Marcus Ward as he begins the mash. *Brian Sorensen.*

Park (the minor-league baseball stadium) and the Argenta Historic District. Flyway Brewing Company and a Core Brewing Company taproom would locate in the area a few years later to create a miniature brewing district.

Melton closed on the deal for the Orbea property in June 2013. The move north of the Arkansas River raised a few eyebrows in Little Rock. Competition between the capital city and its neighbor opposite the river was at times fierce. Some considered Diamond Bear's move as some sort of political statement, although Melton said nothing could be further from the truth. "North Little Rock did a very good job," he said. "The mayor recruited us, yes, but we were looking on both sides of the river." Melton said he doesn't make a big deal out of being in North Little Rock versus being in Little Rock. "Our customers don't care about that stuff. And I still tell people we're in Little Rock. For a customer from Texas it's the same thing."

A large grain silo sits outside the new brewery in North Little Rock. *Brian Sorensen.*

Names of fermenters at Diamond Bear Brewing Company include Laverne and Shirley. *Arkansas Department of Parks and Tourism.*

The move to the bigger facility took place over the summer of 2014. It was fiscally challenging to take down production while the move was executed. "We brewed our last batch [at the old location] at the end of April," said Melton. "We had to be out in May, but our equipment was about three months late. Walmart was mad at us because we were out of stock." Eventually, Diamond Bear got its new 30-barrel brewhouse from Custom Metal Craft in Springfield, Missouri, up and running. Three 120-barrel fermenters and a 120-barrel bright tank now handle the brewery's fermentation duties. Several 60-barrel fermenters are in use as well. The 1,500-square-foot Arkansas Alehouse—Melton's first attempt at the food business—opened alongside the new brewery. The restaurant, which serves double-duty as the taproom, provides seating for more than 150 people and has a retail space and private party capabilities. Visitors can see Laverne, Shirley, Moe and Larry (other named brewery vessels) through taproom windows. Diamond Bear currently brews several beers, including Presidential IPA, Two Term Imperial IPA, Paradise Porter and Dogtown Brown. Seasonal offerings include Irish Red, Honey Weiss, Strawberry Blonde, Rocktoberfest and Oatmeal Stout.

Melton built his brewery for the state of Arkansas. He wanted Arkansans to consider Diamond Bear their home state beer. "[Former University of Arkansas football coach] Frank Broyles was clever in the way he promoted the Razorbacks," said Melton. "He knew the program needed the whole state's support, and that's what he went after." "BEER OF ARKANSAS" is written in bold letters above the entrance to the brewery, and Melton clearly relishes his role as one of the state's brewing pioneers. There were several false starts before his arrival, but he proved that an Arkansas-produced beer can be successful over the long haul. Somewhere, sitting behind a mahogany desk, a skeptical banker is kicking himself.

BREWING IN THE OZARKS

Some might argue that Fayetteville, Arkansas, is the definitive college town. Rolling hills and a live-and-let-live attitude provide a backdrop for more than twenty thousand students, faculty and staff who flock to the University of Arkansas each fall. And they come from all over the state—from nearby towns and far-flung Arkansas cities like Batesville, Mountain Home and Pine Bluff. They learn early on to "call the Hogs" in support of the home team. Even the Texans—who now attend classes at the University of Arkansas in droves—root Hog or die.

Fayetteville is known as a liberal town in a very conservative state. Hippies and back-to-the-earth types have long sought refuge in the hills and hollers that surround the place. Do-it-yourself is the calling card of the Ozarks. Small farms dot the countryside, and farmers bring their goods to the downtown market every Saturday morning. Leisure is just as valued as hard work, however, and locals are increasingly spending their free time sipping on beer at one of the numerous breweries that has opened since 2010.

Of course, there's more to Northwest Arkansas than Fayetteville alone. Neighbors to the north—Springdale, Rogers and Bentonville—have considerable populations of their own, and each has a craft brewery or two as well. The Northwest Arkansas beer industry has grown to the point that most of the region's 500,000 inhabitants are now within a ten- to fifteen-minute drive of a brewery.

The towns that make up Northwest Arkansas each have their own personality. Springdale is home to the world's largest protein producer, Tyson

Northwest Arkansas is a half-day drive from some of the most beautiful places on earth, such as Triple Falls near the Buffalo River. *Brian Sorensen.*

Foods, and maintains a strong blue-collar reputation. Several manufacturers are located in Springdale, as are the Northwest Arkansas Naturals (the AA affiliate of the Kansas City Royals) and a new campus of Arkansas Children's Hospital. Rogers is extremely diverse with a second- and third-generation Hispanic population and thriving retail and entertainment districts. Bentonville, the birthplace of Sam Walton's retail dynasty, is quickly gaining attention for the rebirth of its downtown area. It's home to some of the area's most popular arts destinations, including the Crystal Bridges Museum

of American Art. Actress Geena Davis hosts the Bentonville Film Festival in the city each year, bringing a number of celebrities to town.

The breweries in the region are as diverse as the cities they call home. They range from big to small and from traditional to experimental. Due to sheer number and distance between, they are hard to visit in just one day. They are best experienced over the course of a weekend, with a designated driver to ensure safe passage.

Hog Haus Brewing Company (2004)
430 West Dickson Street, Fayetteville

Julie Sill moved to Fayetteville in 1991 to play soccer at the University of Arkansas. Soon after arriving, she sustained a serious injury to her leg; all of a sudden, her playing career was over. Fortunately, she was able to finish her degree on scholarship. After graduation, she started waiting tables, which eventually turned into a full-blown career in the restaurant business.

After stints at Cuckoo's (one of Fayetteville's first sports bars) and Jose's Mexican Restaurant, Sill served as the manager at Emerald Coast on Dickson Street. When it closed in 1997, Sill partnered with Kari Larson and opened the Common Grounds in the same space. It became a popular hangout for Fayetteville residents and college students. Just as local beer was in short supply in those days, so, too, was good coffee. The Common Grounds attracted a loyal following, and sales receipts reflected the shop's popularity. When John Gilliam announced that he was closing Ozark Brewing Company in 2004, Sill and Larson decided to buy him out. Sill said that many people were worried that outside interests would take over the landmark brewery. Keeping it local was important to the Fayetteville community, and the enterprising pair of young businesswomen delivered.

After eight years of success at Common Grounds, Sill and Larson officially took ownership of what they dubbed Hog Haus Brewing Company. All of the original brewing equipment transferred with the purchase, as did the brewer. Gilliam agreed to continue handling the brewing duties to ease the transition. He focused on the beer, and Sill and Larson handled the kitchen and front-of-house operation. The arrangement worked extremely well because everyone played to their strengths.

Gilliam eventually moved on, and Hog Haus cycled through brewers for a time looking for a good fit. There were several who demonstrated

The brewhouse at Hog Haus Brewing Company sits dormant for now. *Brian Sorensen.*

great talent on the brewing system, but turnover at the position was high. Steve Mazylewski was one whom many people fondly remember despite only being at Hog Haus for a short trime. The Chicago-area native had worked at several breweries back in his home state of Illinois and made a good first impression on Fayetteville beer drinkers after being hired by Hog Haus in 2007. He found a few sanitation issues inside the brewery that had been giving management fits. Mazylewski replaced some transfer equipment, and the beer improved significantly. "Now we are turning the operation around and giving the people of Fayetteville local beer they can enjoy and be proud of," Mazylewski told Missouri State University researcher Jeremy George in 1998. "This has changed the whole situation tremendously." Hog Haus beers made during this time included Curly Tail Ale, British IPA, Saison and Java Porter. Mazylewski even attempted a few lagers during his time in Fayetteville.

Mazylewski eventually returned to the Chicago area and left Hog Haus looking for another brewer. Eventually, a deal was struck with Jesse Core to brew Hog Haus beers along with a few others under the Core Brewing

Hog Haus Brewing Company operates inside the former Ozark Brewing Company on Fayetteville's Dickson Street. *Brian Sorensen.*

name. The plan was to eventually brew all of Hog Haus beers at Core's new production facility in Springdale, but the partnership fell apart amid contractual disagreements. Hog Haus filed suit against Core, and he countersued. When the dust settled, Core moved on to focus on his new brewery, and Hog Haus contracted with Saddlebock Brewery to produce its beer in Springdale.

Hog Haus had been stymied by the revolving door in the brewhouse, and Sill thought that having the beer brewed on contract would improve the quality of the beer. "I said, 'Steve, brew it, we'll buy it from you, and we'll see what happens,'" she said, referring to Steve Rehbock of Saddleback. There may come a time when she is ready to hire another brewer. Sill, who has high expectations for everyone she works with, said it will take a special person to make that happen. "If you're going to come here and take a risk," she said, "you have to have confidence in yourself because I'm going to put pressure on you to do well. I don't want anyone else coming in here until I know that they are ready to be a brewer on Dickson Street." In 2015, Sill and Larson untangled their business interests, with Sill maintaining ownership of Hog Haus and Larson keeping Common Grounds.

Core Brewing Company (2010)
2470 Lowell Road, Springdale

Jesse Core is a seventh-generation Arkansan who was born and raised in Fort Smith, Arkansas. At one point, he was a waiter at Weidman's Old Fort Brew Pub, which was a bit of foreshadowing given his future occupation. "I was just a kid at the time," said Core. "I once asked Daniel Weidman if I could be his apprentice. He chose not to do that for whatever reason, but I've always had this burning desire to be a brewer."

Core played baseball at Westark Community College in Fort Smith after graduating from the city's Northside High School. At Westark, he met a microbiology professor who used his own love of homebrewing to motivate Core to do his best in class. The deal was that if Core would show up and give maximum effort, the professor would teach him how to brew. The seed was officially planted. Core then moved on to Harding University to complete his degree and, after graduating, started working professionally as a computer programmer. Work assignments took him to some of the best beer cities in America. He spent extended time in both San Diego and Boulder when those cities' respective beer cultures were just coming into their own. Core experienced firsthand what craft beer could do for communities and their local economies. In 2005, he moved back to Arkansas to work for Tyson Foods in its information systems department. He also served on the Springdale City Council for a term. In many regards, things were going well for Core, although he had yet to scratch his brewing itch.

Eventually, Core started to get serious about a professional brewing career. He worked on a business plan for about eighteen months, but like many prospective brewers in Arkansas, he was met with heavy doses of skepticism from local banks. Core's very first investor was his former supervisor at Tyson Foods. "I didn't know I was the first one," said Dave O'Brien. "He didn't necessarily share that with me. I thought everyone was doing it so I better hurry up and get in!" More investors followed suit, including several high-profile Northwest Arkansas businessmen. As compared to other brewery startups in the region, Core's venture was one of the most organized and well financed. More than $1 million was initially raised to start the brewery.

Core Brewing Company opened on a small scale in September 2010. Back then, Core was brewing on a one-barrel system with only eight small fermenters. The beer was sold to Kingfish, a dive bar in Fayetteville's

downtown entertainment district. Core sent two kegs to the bar every Thursday, and the bar's customers gave Core feedback about what they did and did not like about his beer. This allowed him to further refine his recipes and prepare for bigger production runs once his brewery was completed in Springdale. The brand new twenty-five-barrel brewhouse and four twenty-five-barrel fermenters (plus two bright tanks) were finally ready to go in 2012. With the aforementioned legal issues with Hog Haus Brewing Company behind him, Core was set to brew on a scale much larger than he had ever brewed on before.

Core came out of the gate fast. Northwest Arkansas was instantly covered with the brewery's beer and merchandise. The wiener dog logo was a ubiquitous sight throughout the region. Core was himself a proud Arkansan, and being respected by the community was important to him. "We want to be Arkansas's premium brand," he said shortly after shifting production to Springdale. "So when you go out of state and wear one of our shirts, you can proudly say—'Core, that's my brewery.'" Initial offerings included Arkansas Red, Hilltop IPA and Leghound Lager (a traditional Oktoberfest-style lager). ESB—based on one of Core's homebrew recipes—served as the flagship offering from the start.

In August 2013, the taproom moved to a 1,500-square-foot space a few doors down from its previous location. The vast industrial complex the brewery calls home is made up of several modular sections that have provided Core opportunities to expand over time. Additional space was obtained with room for ten new fifty-barrel fermenters and five fifty-barrel bright tanks. Keeping up with demand—which was starting to come from neighboring states—was a challenge for the young brewery. Core beer could be found in places such as Nashville, Atlanta and Oklahoma. It was even available in South Dakota for a short time. Needless to say, additional capacity was key for growth.

In late 2014, Core introduced the first of several satellite taprooms in the region. The Rogers "public house" was located in a swank part of town near Interstate 49. The strategy was simple: serve the brewery's beer in a no fuss, no muss environment. "What I want is for people to come in, hang out with their buddies and drink some beer," said Core. His vision for his neighborhood locations was similar to what English beer drinkers have known for years—the pub as a gateway between work and home. "My perfect location would be between your work and your house, so you can drive there, have a beer and decompress before heading home," said Core.

Core later opened public houses in Fort Smith (March 2015), Springdale (May 2015), Fayetteville (June 2015), the Northwest Arkansas Regional Airport (February 2016), North Little Rock (March 2016) and in downtown Springdale (August 2016). A downtown Bentonville location was later added. More are expected to open soon, including a second location in Fayetteville and new pubs in Tulsa and Springfield, Missouri.

A significant rebranding effort was launched in 2015. Packaging was redesigned, and a new streamlined logo was unveiled. The wiener dog mascot—chosen to honor a beloved pet named Barney—remained. It held a special place in Core's heart and was considered an untouchable brand image. Easier-to-read wording and bright colors were implemented to stand out to shoppers trying to navigate busy retail beer coolers. A year later, a significant expansion took place. Three 160-barrel glycol-chilled fermenters and a 160-barrel bright tank were installed, and a new canning line that increased output from 24 cans per minute to 250 per minute was purchased for $750,000. Core estimated brewing output was around 6,000 barrels in 2016.

Distilling was at one point included in the brewery's official name. Core announced plans to convert the former Southwest Times Record building in downtown Fort Smith into a functioning distillery, where he intended to make bourbon, rum and brandy. Additionally, he planned to partner with his former school—now known as the University of Arkansas–Fort Smith—to start a trade program for future brewers and distillers. A dean of the program has been identified, but several details still need to be worked out. "We don't just want to do a fermentation science program," said Core. "We want to validate brewing and distilling as a career. It will be a difficult degree to obtain. Students will need to understand biochemistry principles, microbiology, math and engineering." In February 2017, the brewery announced that it was scrapping its plans for the distillery. The early indication was that the project was not entirely dead, but rather delayed, and potentially slated to reemerge somewhere in eastern Arkansas at some point in the future.

Core Brewing Company has built tremendous brand awareness since moving into its Springdale home in 2012. "My goal from the beginning was to be a relevant and meaningful brewery," said Core. As one of the top beer producers in the state, and with a taproom presence in several towns, he has already accomplished that goal and more.

West Mountain Brewing Company (2011)
21 West Mountain Street, Fayetteville

John Schmuecker came to Northwest Arkansas as a student and never left. The Iowa native originally moved to Mountain Home, Arkansas, with his family when he was in the eighth grade, and then later to Fayetteville to attend the University of Arkansas. There he studied geography and discovered an intense love for an emerging sport. And on January 1, 1985, he started a job that would alter the course of his life forever.

Back in Iowa, Schmuecker's father, Tom, owned a fly tying company called Wapsi Fly. In 1978, the family moved the business to Mountain Home to be in a warmer climate and closer to the emerging fly-fishing industry of northern Arkansas. The relocation was rough on Schmuecker. He was a kid from "up north" trying to fit in to the unique culture of the Ozark Mountains. He stood out like a sore thumb, and that made him an easy target for bullies. He recalled one harrowing event that involved a punch to the mouth and a broken jaw—just a month after arriving in town. "I didn't see it coming," said Schmuecker. A trip to the school nurse (whom he remembers as "cute") helped ease his pain, but deep down he knew he was an outsider in a small town.

Schmuecker's older brothers graduated from high school and went to college in Fayetteville, as he did in the fall of 1983. An outstanding swimmer, he joined the school's swim team. Training was harsh. The coach would attach five harnesses to a boat and demand that swimmers pull him around Lake Wedington as a part of a grueling training regimen. It didn't take long for Schmuecker to decide that varsity sports weren't for him. Later, his brother Joe introduced him to ultimate Frisbee. Schmuecker took to it like a duck to water. School was somewhat of a different matter. He majored in geology, although he didn't know what he was going to do with that particular degree. He assumed that a career in the fly tying business back in Mountain Home was his likely next step.

As time passed, Schmuecker found himself playing more and more ultimate Frisbee. He was intent on staying in Fayetteville so he could play as much of the sport as possible. In 1985, he started working for Mel Cranston at a popular pizza shop—Tiny Tim's Pizza—on Fayetteville's downtown square. The restaurant (which opened in 1981) occupied a building with a bit of a checkered past. According to Schmuecker, the basement had once been used as a bordello. And years later, after a local attorney vacated the upstairs portion of the building, several .38 slugs

were pulled from the walls. There's no telling what kind of shenanigans led to gunfire.

Cranston eventually decided to sell his three pizza restaurants (he owned two others under the Tiny Tim's name). Schmuecker, who had worked at Tiny Tim's on the downtown square for eleven years, purchased the location from his boss on January 1, 1996. His dream of staying in Fayetteville was all of a sudden a reality. The deal presented an unexpected challenge for Schmuecker. "Going from a fellow employee to the boss was a big transition," he said. It wasn't until the crew completely turned over that he became comfortable as the leader. He worked hard to run Tiny Tim's, barely taking any time off in the process. "My record was 237 straight days opening the restaurant," he said. Bookending that streak were two ultimate Frisbee tournaments—the only acceptable excuse for Schumuecker to miss work. Many of the tournaments back then took place in Lawrence, Kansas (about four hours from Fayetteville). It was there that he discovered beer from Kansas City's Boulevard Brewing Company. The brewery's pale ale, in particular, left a lasting impression. Tiny Tim's Pizza would later become Boulevard's first draft account in Arkansas.

Schmuecker soon started homebrewing, buying his ingredients from the local homebrew supply shop in Fayetteville. His most memorable batch was a cherry stout, which weighed in at more than 9 percent ABV. He served the beer at an employee meeting, and it was met with rave reviews. Schmuecker said that he wants to one day brew that recipe again if he can ever find it.

One night in 1998, after leaving Tiny Tim's—which at the time occupied the eastern portion of the building—Schmuecker looked at the vacant space next door and had an epiphany of sorts. He could easily punch a hole in the wall that divided the two areas and install a brewery of his own. Having recently broken up with a longtime girlfriend, and needing a project to throw himself into, he decided right then and there to become a professional brewer. He signed a lease on the adjoining space and made plans to open West Mountain Brewing Company. Schmuecker purchased brewing equipment from a Canadian company the next year, but unfortunately the supplier failed to send everything needed to put it all together. Before amends could be made, the company filed for bankruptcy and went out of business. Schmuecker did not possess the kind of know-how necessary to get the brewhouse working, so it sat dormant for nearly a decade. A sign on the front window declaring that West Mountain Brewing Company was "coming soon" was a peculiar mark on the downtown square. "It was a big joke in town," said Schmuecker,

West Mountain Brewing Company anchors the southwest corner of Fayetteville's downtown square. *Arkansas Department of Parks and Tourism.*

referring to the empty brewing vessels in the window of the brewery. "I was thinking about putting ranch dressing in them." He was obviously kidding, although the frustration he experienced over those years was 100 percent real.

Then, in the fall of 2010, a young brewer named Andy Coates walked into West Mountain while taking a stroll around the square. He had recently moved to Northwest Arkansas with his wife, Lacie Bray. Coates, who had gained brewing experience at Chicago's Goose Island Brewing Company and Great Divide Brewing Company in Denver, was excited to taste beer made in his newly adopted hometown. He was disappointed to learn that the brewery was idle and there were no house beers on tap. Sensing opportunity, he left his phone number with the bartender and asked that the owner give him a call. Schmuecker called him back that day and made an instant connection. "He was an exceptionally nice guy and had all kinds of qualifications and experience," said Schmuecker. "And being from Iowa, I knew he was somebody I could trust." West Mountain's long-awaited arrival was about to happen. House-made beer flowed from the brewery's taps in November 2011. The first was appropriately named Coming Soon Pale Ale.

The brewery at West Mountain consists of a 3.5-barrel brewhouse and two 7-barrel fermenters. Everything sits in a space approximately two hundred square feet in size. To say it is cramped is an understatement. With such a small system and only a few fermenters, keeping up with demand was a challenge from the start. The IPA was especially popular and hard to keep on tap. Coates kept his IPA relatively simple, with a sixty-minute hop addition and another addition to the whirlpool. He then dry-hopped with a pound per barrel. Coates took pride in creating highly drinkable beers that many people now call session ales.

Coates eventually left West Mountain to start his own brewery in Rogers (Ozark Beer Company), and Will Gallaspy was hired as his replacement. Gallaspy brewed at Bosco's in Little Rock and at Parish Brewing Company in Broussard, Louisiana, before arriving in Fayetteville. When he departed a year later, Ryan Pickop was hired to take his place. Pickop was an Americana musician and former distiller at Balcones in Waco, Texas, who moved to Fayetteville for opportunities in music. In late 2016, Minnesota-native Casey Letellier took over the brewing duties at West Mountain.

West Mountain Brewing Company caters to a diverse crowd. The original space is open and airy and is frequented by families. Floor-to-ceiling windows open the restaurant up to the plaza between the dining room and the Fayetteville Town Center next door. The brewery side is somewhat dark and tavern-like, with wood-paneled walls and a long bar that is frequented by some interesting locals. A happy hour is offered every day from 4:00 p.m. to 6:00 p.m., lubricating conversations that bounce between politics, sports and philosophy. It's not uncommon to find professors from the nearby university enjoying their pints next to farmers or construction workers. It is a microcosm of Fayetteville itself—a diverse and tolerant place that pairs well with a good beer.

Tanglewood Branch Brewing Company (2012–14)
Fayetteville

J.T. Wampler was a shutterbug, capturing the images of Northwest Arkansas for local newspapers for more than fifteen years. He was also a fan of good beer and a longtime homebrewer. Succumbing to the same temptation that turns many amateurs pro, he opened Tanglewood Branch Brewing Company in 2011. It was a short-lived affair, but Wampler's tiny brewery

proved that good beer and working-class neighborhoods were not mutually exclusive. In the process, he created an environment that helped foster the expansion of beer culture in Northwest Arkansas.

Tanglewood Branch was located at the intersection of South School Avenue and Fifteenth Street in South Fayetteville. The area was economically challenged, and vagrancy was relatively commonplace. Once a gas station and convenience store, the building Tanglewood called home was a frequent hangout for the homeless population. Sociology students at the university were often sent there for field observations as a part of their coursework. Watching the homeless and mentally ill shuffle in and out was quite an eye opener for students who didn't typically venture far from campus. While the rest of Northwest Arkansas seemed to thrive, the area surrounding the Petra Stop—as it was then known—seemed to slide further and further into disarray. So it seemed a bit odd that a new business, one that seemed to cater to a more affluent demographic, would choose to locate in such a place. The area appealed to Wampler, however, for the very reasons that turned others away. There weren't many amenities in South Fayetteville, and the folks down there deserved something to be proud of. Wampler decided he was just the guy to give it to them.

It took Wampler thirty-three days to gut the store and install new drains. Aesthetically, Wampler's goal was to create a neighborhood pub environment like those found in England. There weren't many windows at Tanglewood (which was named for a nearby creek). The place was relatively nondescript. For the most part, people didn't even realize it was going to be a brewery when the work started. The permitting process took a bit longer than Wampler hoped, so when the pub opened in September 2011, the focus was strictly on food (made from scratch from locally sourced ingredients) and a well-curated offering of local and regional beers. Tanglewood Branch finally secured its brewing permits in March 2012, and house beer flowed two months later.

The brewhouse was quaint compared to other brewpub systems around the state. Wampler mashed grain and boiled wort in old kegs. He had plenty of space in the 2,600-square-foot store to expand, but small batches were his forte. Wampler brewed twenty-five gallons at a time, up to three times per week. Some of the more notable Tanglewood beers included South Side Porter, EKG IPA, The Fifth's Ale and Proper 1420.

Many breweries claim to be unpretentious, but Tanglewood Branch almost required people to drop their egos at the door. A special happy hour was offered to patrons who walked or biked and didn't take up a parking space with a vehicle. The brewpub had a family-friendly environment, with deep couches

and board games to keep people entertained. The priority—as Wampler saw it—was good conversation instead of digital distractions. Televisions were noticeably absent from the walls. Musicians of various genres played at the brewpub on a regular basis, making it a haven for creative types.

Wampler intended to upgrade to a seven-barrel system at some point. He hit a financial rough patch, however, and the survival of his business was suddenly in jeopardy. In December 2013, he posted on the brewery's Facebook page that Tanglewood Branch would soon close "unless a Christmas miracle happens." Wampler started a crowdfunding campaign to save the business. More than one hundred fans of the brewery responded, with donations exceeding $21,000. Unfortunately, the additional funding only meant another nine months of operation. Tanglewood Branch lost the lease on its location in September 2014 and was forced to close its doors for good. Wampler wrote the following message on the brewery's Facebook page:

> *It is with much sadness that we must announce the closing of our beloved pub. We have lost our lease and moving to a new location is out of the question, so we are forced to cease operations. We will continue to sell beer through the month of September then close for good sometime next week. I appreciate all of you who believed in the dream of bringing craft beer to South Fayetteville. I fear we were a bit ahead of our time. Thank you again for your support over these last three years. It was a heckuva ride.*

Tanglewood Branch Brewing Company was part of the local beer scene for only a brief moment, but the brewery's legacy is secure. There weren't many breweries in the state when the doors opened, let alone one in a neighborhood as challenged as South Fayetteville. Wampler demonstrated great courage in chasing his dreams and for expanding the scope of local beer. He returned to professional photography and still lives in Northwest Arkansas—and homebrews as much as he can.

Fossil Cove Brewing Company (2012)
1946 North Birch Avenue, Fayetteville

Ben Mills looks like a brewer. The Gravette, Arkansas native has a beard and is extremely laidback. He blends effortlessly with the crowd inside his brewery, Fossil Cove Brewing Company. The neighborhood outside is gritty, but it

Fossil Cove Brewing Company opened in midtown Fayetteville in June 2012. *Brian Sorensen.*

doesn't keep people from flocking to the tasting room on most nights. Even by Fayetteville standards, the crowd is eclectic. Blue-collar workers mingle with graduate students from the university and white-collar professionals. "There's no judgment," said Mills, referring to the mood inside the Fossil Cove taproom. "We don't really have a target demographic. People who like craft beer are going to find us; there's no class system here."

Before arriving in Fayetteville, Mills attended Arkansas Tech University in Russellville, Arkansas. He was a biology major intent on becoming an environmentalist after graduation. For a brief time, he took up winemaking in his campus apartment. The results were less than ideal, however, so he switched to brewing beer instead. Mills was immediately hooked on the hobby. He was so smitten with brewing, in fact, that he attended a six-month brewing program at the University of California–Davis. He also worked at Silverton Brewing Company in Colorado for a time, supplementing his newly acquired book knowledge with some much needed hands-on experience.

With the support of his parents (who are also his partners), Mills bought a complete brewing system while working at Silverton. The system was placed in storage for a few years while Mills decided where to locate his brewery. Very little outside money was raised in the process of startup, which freed Mills to make decisions that best aligned with his goals. Ultimately, he

decided that Fayetteville—the hip college town that was also experiencing an economic boom—was the right location for Fossil Cove. In hindsight, the timing couldn't have been better.

Fossil Cove—which is named for a section of Beaver Lake that Mills frequented as a boy—officially opened for business in June 2012. Mills, then just twenty-five years old, started out with a four-barrel brewhouse from Ripley Stainless Limited. Distribution was limited at that point, with most of the beer sold in the taproom. Initial offerings included T-Rex Tripel, La Brae Brown and an IPA. Area residents were excited to have a new brewery in town, and as the crowds grew, Mills was challenged to keep up with demand.

Experimentation was a part of Mills' game plan from the very beginning. In July 2013, he brewed the first known commercial sour in Northwest

Owner Ben Mills opened Fossil Cove Brewing Company after studying at UC–Davis and gaining experience at a Colorado brewery. *Brian Sorensen.*

Arkansas. Based on a recipe from *Basic Brewing Radio*'s James Spencer, wort was spiked with lactobacillus in the mash tun prior to boiling. The resulting Berliner Weisse was released amid much fanfare on August 10 of that year. Andy Sparks, the owner of the local homebrew supply shop, provided traditional raspberry and woodruff syrups to complement the beer. The festivities that day were a testament to how much excitement was building inside the local beer community.

More innovation came in December 2014 when Fossil Cove introduced a coffee IPA that incorporated beans from local coffee roaster Onyx Coffee Lab. At the time, there were very few examples of coffee IPAs in existence. Fossil Cove has since followed up with an annual release of the special brew. Other seasonal beers produced by the brewery include Blizzle (a black IPA), Whizzle (a white IPA) and Hoppy Wheat.

For the first three years, food trucks were the norm outside the brewery. Then, in June 2015, a permanent food option was introduced. Mills partnered with Little Bread Company co-owner Mitchell Owens to open the Container Kitchen—a shipping container that was retrofitted with a working kitchen. Menu items (which included sliders, tacos and specialty French fries) were all made from scratch using fresh ingredients. Then, a month later, Fossil Cove introduced canned versions of its beer. They were some of the very first cans from a Northwest Arkansas brewery (to that point, only Core had canned any beer). The designs utilized prehistoric images originally created for Fossil Cove by local artist Nick Shoulders. BLKBOXLabs, a design and marketing firm based in Fayetteville, helped refine the look for packaging. Mills saw the benefit in investing in good design. "On the very first purchase people are definitely judging the book by its cover," he said. "It's all about individuality. People don't want to see everyone looking the same." Cans of La Brea Brown and Paleo Ale were available exclusively in the taproom at

Most beer brewed by Fossil Cove Brewing Company is sold in its taproom, which is quite popular with locals. *Fossil Cove Brewing Company.*

first, but as the brewery's capacity grew, began making their way into the local market.

Fossil Cove has always been a small brewery. Capacity hovers around two thousand barrels per year. Growth has been constant but deliberately paced. "The way things are rolling now, we're doing a pretty good job of spending money when we have money," said Mills. Two twenty-barrel fermenters were installed in late 2015 to help the brewery keep up with demand. That same year, Mills announced that he was working with architects from Modus Studios to design a new brewery and taproom around the corner from the existing location. A winter beer festival called Frost Fest was held on the property in February 2016, in part to celebrate the future home of Fossil Cove Brewing Company. The event was wildly successful, and in 2017, it moved to a much larger venue near the Washington County Fairgrounds. An unforgettable image from both events was Ben Mills roaming the festival grounds in an abominable snowman costume, posing for pictures and clearly enjoying the fruits of his labor.

Saddlebock Brewery (2012)
18244 Habberton Road, Springdale

Steve Rehbock was a prolific homebrewer. When he took up the hobby in 2008, he thought about brewing every day and night. The former homebuilder and software consultant was brewing as much as three or four times each week, perhaps more. Once a month was a more typical pace for homebrewers—maybe twice if someone was completely gung-ho. Rehbock was a fixture at FLOPS meetings. He soaked up as much constructive feedback as he could from his fellow hobbyists. The more he brewed, the more he wanted to brew. It was turning into a self-fulfilling prophecy, almost as though going pro was the only possible outcome.

Rehbock, a Chicago native, opened Saddlebock Brewery in 2012. The horse barn–inspired brewery is nestled into the rolling hills east of Springdale and is just a fifteen-minute drive from the main population corridor of Northwest Arkansas. It is, however, worlds apart from the other breweries in the region. Saddlebock's rural setting along the White River makes it unique. The brewery's design blends perfectly with the horse farm aesthetic that surrounds it. "It looks like a horse could walk out of here at any minute," said Rehbock, referring to the brewery that he built with his own hands.

Nestled into the Arkansas countryside, Saddlebock Brewery was designed to resemble a horse barn. *Brian Sorensen.*

Rehbock and his now-ex-wife, Carolyn, financed most of the brewery's startup themselves. Carolyn Rehbock was a successful marketing executive and supported her husband's efforts to start a brewery. Her marketing expertise played a key role in shaping the business. Her love for horses inspired the brewery's name, and much of Saddlebock's early branding efforts showed her influence. Investment opportunities were initially offered to a limited number of family and friends. In total, nearly $500,000 was raised to start the brewery.

The money provided for the construction of a 4,100-square-foot brewing facility that Steve Rehbock designed himself. His goal was to create a brewery that was as energy efficient as possible. The three-story structure uses gravity to move ingredients and liquids through the various steps of the brewing process. Pre-milled grain and other supplies are stored on the upper floor. The mash tun and boil kettle sit on the floor below, and fermentation vessels are found in the cellar (where temperatures are consistently in the upper sixties). The process is a throwback to the way Joseph Knoble did things in his Fort Smith brewery in the mid-1800s.

Rehbock started with a fifteen-barrel brewhouse designed by Custom Metal Craft in Springfield, Missouri. A thirty-barrel fermenter and a

Stever Rehbock of Saddlebock Brewery conducts an interview. *Brian Sorensen.*

thirty-barrel bright tank handled fermentation duties. Also in use were four twenty-four-barrel open fermenters, which Steve Rehbock used to finish Saddlebock's dunkelweizen and hefeweizen beers.

In the beginning, Saddlebock beer was only offered in the taproom and at draft accounts in Northwest Arkansas. Soon it was distributed in twenty-two-ounce bottles and in one-gallon growlers to retail beer stores. While growlers were common take-home purchases at breweries, they were never before seen at off-premises retail accounts in Northwest Arkansas. Saddlebock was the only one doing it at the time. Dirty Blonde and Arkansas Farmhouse were two of the most popular beers from the brewery in those early days.

In 2013, Yahoo Travel named Saddlebock one of the five "Coolest Craft Beer Tours in America." Steve Rehbock was excited to receive the recognition but wasn't stunned that people were having fun at his brewery. "We're finding that people who come to the brewery really like the experience out here because we're unlike anything else they've experienced," he said. Volleyball courts and small cottages were offered to the public on a rental basis. River access allowed for brewery-organized float trips, and a café was built across the road from the main brewery. Steve Rehbock was doing his best to turn his brewery into a destination, and people started to take notice.

In 2014, Rehbock signed an agreement with the owners of Hog Haus Brewing Company in downtown Fayetteville to brew their beer. To accommodate the growth in demand for its own beers—and with the

additional volume from Hog Haus—Saddlebock added two thirty-barrel fermenters in July of that year. The tasting room underwent a significant expansion in November. A third deck was later added to increase outdoor seating options. Saddlebock started canning its beer in October 2015.

Saddlebock Brewery offers a wide variety of beers, including a staggering fifteen or more in its taproom. Rehbock enjoys working with different ingredients and playing around with recipes—he is still a homebrewer at heart. Farmhouse Ale is brewed with rice and grits from nearby War Eagle Mill, and Winter Daze—a vanilla porter aged in oak bourbon barrels—has been one of the most well-regarded beers Saddlebock has brewed since opening.

Apple Blossom Brewing Company (2013)
1550 Zion Road #1, Fayetteville

Amid all the excitement surrounding new breweries in Northwest Arkansas, there was still a shortage of old-fashioned brewpubs. West Mountain and Hog Haus were the only two in the area; all the other breweries relied on the food truck model and didn't offer a true dining experience. A few members of the local restaurant and bar community seized the opportunity and started a brewpub on the north side of Fayetteville. To the delight of local beer drinkers and foodies alike, Apple Blossom Brewing Company opened in July 2013.

Evan McDonald—one of the brewpub's co-owners—moved to Northwest Arkansas in 2005 with the idea of opening a cidery. Shortly after arriving, he met Sammie Stephenson, who was working as a shift manager at Tiny Tim's Pizza on Fayetteville's downtown square. The two hit it off, and McDonald was hired for the kitchen crew. Eventually, the cider idea became a regular topic of discussion. It morphed into an idea for a brewery, but unfortunately, the Great Recession of 2007–9 happened and the dream was shelved. Launching a brewpub concept in a hurting economy was simply not in the cards.

Back then, Hog Haus Brewing Company was the only brewery in operation in Northwest Arkansas. Most people didn't see the feasibility of making beer at that point; certainly not the people who had money to lend. To build credibility—and perhaps, just as importantly, cash flow—the duo partnered with local restaurateurs Joe Utsch and Al Schaffer to open Smoke & Barrel Tavern just off Dickson Street. Smoke & Barrel quickly became known for its superb selection of whiskey and crowd-pleasing live music.

After two successful years, the bar's owners decided the time was finally right to make a run at the brewery idea. They took on two additional partners—Ching Mong and Daniel Smith—and the plans for Apple Blossom Brewing Company started to take shape.

The six partners leased space in a brand new 8,500-square-foot building near Veteran's Park in north Fayetteville. The area was somewhat underserved in terms of restaurant options, and the location put the brewpub in a convenient spot next to the Razorback Regional Greenway trail system. A ten-barrel brewhouse was installed. The building provided a nice clean layout with plenty of room for growth. Nathan Traw, a former quality assurance technician with Mother's Brewing Company in Springfield, Missouri, was hired as the first brewer at Apple Blossom. He brought an adventurous spirit to the job, brewing beers such as Ozark Smokehouse Porter (made with hambone) and Sturdy Hippy IPA (inoculated with sourdough yeast from the in-house bakery). Soulless Ginger Ale, a tongue-in-cheek reference to redheaded co-owner Smith, was another popular beer created by Traw. Some of Apple Blossom's other offerings back then included Fayetteweisse, Armstrong American Pale Ale and Hazy Morning Coffee Stout.

In late 2014, Traw left Apple Blossom for Core Brewing Company in Springdale. Marcus Ward, a longtime homebrewer who had brewed with Andy Coates at West Mountain Brewing Company, was hired as Traw's replacement. "[Coates] pretty much taught me everything I know about large-scale brewing," said Ward. Apple Blossom collaborated with other Arkansas brewers, including Bike Rack Brewing Company, Foster's Pint and Plate and Moody Brews from Little Rock. Earl Grey ESB, the collaboration with Moody, was a big hit with local beer drinkers. In August 2015, Apple Blossom teamed up with *Basic Brewing Radio*'s James Spencer to brew his cream ale recipe. Previous episodes of the show documented experiments conducted to choose the yeast strain for the beer. Brian Youngblood, formerly of Vino's Brewpub in Little Rock and Transplants Brewing Company in California, replaced Ward as Apple Blossom's head brewer midway through 2016.

Apple Blossom's kitchen puts out a nice variety of sandwiches and entrées. Some of the dishes incorporate beer from the brewery. Specialty bakery products—which are packaged, branded and sold at local stores—are also quite popular. The brewpub's atmosphere is open and inviting, and a large patio provides patrons with a view of the Razorback Regional Greenway. Certainly the consensus among area residents has been that Apple Blossom filled the region's brewpub void quite capably.

Ozark Beer Company (2013)
109 North Arkansas Avenue, Rogers

Andy Coates is a native of Iowa. He has a long beard and wears an Ozark ball cap most of the time. And he possesses one of the most respected resumes among brewers in the state. By the time he arrived in Northwest Arkansas—by way of Chicago, Denver and South America—he had brewed at some of the largest craft breweries in the United States. How he ended up in Arkansas was, of course, related to a girl.

After graduating from Cincinnati's Xavier University, Coates spent a winter as a lift operator at a Colorado ski resort. Ever the outdoorsman, he also worked several summers as a raft guide. One summer, he met a young woman from Rogers, Arkansas, named Lacie Bray. The two started dating and quickly fell in love. In August 2008, they became husband and wife. Opportunities soon sent them to Denver, Colorado, where Coates worked on the packaging line at Great Divide Brewing Company. The hours were long and the pay was poor, but he quickly realized he loved the work. He later enrolled in a brewing program through the American Brewers Guild in Vermont and thereafter completed an eight-week apprenticeship at Goose Island Brewing Company in Chicago. Goose Island hired him on a full-time basis after the apprenticeship was over. His experience at the iconic Chicago brewery was incredibly important to Coates' development as a brewer. There he gained practical experience in packaging, recipe development and barrel-aging beers.

Next, Coates and Bray moved to Washington to work in the local wine industry. During off hours, they traveled the Pacific Northwest visiting breweries. It wasn't long before they had an epiphany—why not open a brewery of their own? The thought appealed to them, but there were more moves to make before they pursued it. In January 2010, they moved to South America to work on an organic farm deep in the bush. In the span of a just a few short years, they had lived all over the Western Hemisphere. They were living life to the fullest and cramming in as many experiences as possible. Coates continued to feel the strong urge to brew, however, and just a few months into the South American adventure, the couple decided that brewing was their ultimate calling. After careful consideration, they chose Northwest Arkansas as the place to start a brewery. "After looking over the laws in Arkansas, paired with the healthy economic climate and underserved craft beer market, it seemed to be a great choice," said Coates. "Lacie grew up in the area and we still have family here, so that definitely helped us make our decision."

Ozark Beer Company co-owners Lacie Bray and Andy Coates sell BCDS at the beer's 2016 release party. *Marty Shutter.*

Coates arrived in Fayetteville in the fall of 2010 without a job. He found interim work at West Mountain Brewing Company, and when not brewing beers for the downtown square pizzeria, worked on a business plan of his own. During his time there, Coates turned West Mountain into a bona fide beer destination for the people of Fayetteville. He brewed several wonderful beers, although his IPA will always stand out to those who frequented the place back then. When word spread that he was leaving his post at West Mountain to open his brewery, people were both sad to see him leave the brewpub and excited to keep him in Northwest Arkansas. In late 2013, he said goodbye to West Mountain and set out to fulfill the vision he shared with his wife.

Coates and Bray partnered with Jefferson Baldwin to start Ozark Beer Company. Coates and Baldwin had hit it off during a previous introduction, and it seemed like a natural fit for everyone involved. Baldwin worked for Acme Brick by day, and at night he helped put the brewery's sales plan together. To this day, he serves as the primary sales force behind Ozark. The new partners started scoping Northwest Arkansas for an acceptable place to build their brewery. Although they weren't set on any particular city in Northwest Arkansas, a 2012 vote to

make Benton County wet opened up several new possibilities. Being one of the first to brew in the county was an attractive idea. They found an old warehouse in Rogers that was big and had approximately two acres to work with. A soccer complex and park were located across the street, and a branch of the Razorback Regional Greenway passed nearby. Coates, Bray and Baldwin were certain that it was the right place—and had enough space—for the first five years of their business plan.

Ozark installed a fifteen-barrel copper-clad brewhouse purchased from Devil's Canyon Brewing Company in San Carlos, California. Three thirty-barrel fermenters and a thirty-barrel bright tank handled fermentation duties. A walk-in cooler from an old grocery store provided cold storage for kegs and ingredients. The taproom was nondescript, even for a small brewery startup. Former office space inside the warehouse housed the taps and merchandise, and most of the seating was out in the brewery. The patchwork of '70s- and '80s-era dining room tables and chairs made it a curiously comfortable place to hang out when the brewery opened in November 2013.

The idea was to start slow and grow over time. Ozark focused on Benton and Washington Counties from the start, and that was it. Coates, Bray and Baldwin didn't realize how fast demand would ramp up. Northwest Arkansas beer drinkers were immediately drawn to the brand. Ozark American Pale Ale was a low-alcohol alternative that moved away from the more typical citrus notes associated with the style. It was more astringent and grassy, albeit in wonderful ways. Cream Stout was a velvety-smooth stout that lacked the bitter, acrid flavors that turn many people away from stouts. An alternate version brewed with Onyx Coffee Lab beans was particularly good. Ozark IPA and the Belgian-style Golden Ale were handsome beers as well. People were officially smitten with Ozark Beer Company.

The vibe surrounding Ozark has been as important to the brewery's success as the quality of the beer. North Arkansas's hill country possesses a unique culture that's built on hard work and a do-it-yourself mentality. The brewery shared a similar mantra on its website

> *We are rooted in a deep tradition of independent, spirited people who live their lives with a resilience and humility rarely seen anywhere else, and where living from the land and crafting your livelihood is the foundation of the culture and identity of this region. In these mountains and at OBC, hard work isn't what we do, it is who we are.*

Early on, Ozark made the decision to can its beer instead of bottle. Cans were becoming more common in craft brewing, and their benefits far outweighed any disadvantages. Plus they fit with Ozark's outdoor image. Bottles are prohibited on Arkansas waterways, so cans are a better option. Ozark enlisted the services of BLKBOXLabs to help with the designs. "They have really nice, simple, clean stuff for their brand," said creative director Jeremy Teff. "What they really wanted to do was connect it to a broader audience." A close friend of Coates designed the brewery's logo—a simple take on the state flag. The can designs expanded on the theme with imagery that invoked the state's natural environment. "With the elk we were trying to play off the Ozark Mountains' outdoor heritage," said Teff, referring to the design for the pale ale cans. *Paste Magazine* named it one of the forty most beautiful craft beer cans in America in 2014. The brewery's other cans sport similar scenery. A campfire is featured on the Belgian-style Golden Ale, and the can for Cream Stout has a buffalo front and center.

Ozark doubled its brewing capacity in September 2014 with the addition of three 30-barrel fermenters and another bright tank. It finished its first full year of production at 1,400 barrels of beer. Ozark installed a new

Ozark Beer Company takes pride in being an Arkansas brewery. *Marty Shutter.*

canning line—the Wild Goose WGC-100—in February 2015, increasing its canning output from five cans per minute to thirty. One month later, Ozark released its first Barrel-Aged Double Cream Stout (BDCS). The beer was aged in Kentucky bourbon barrels over the winter and finished at nearly 11 percent ABV. BDCS featured a big bourbon aroma and notes of vanilla, chocolate, coffee and brownie. A few kegs were infused with cold-brewed coffee from Onyx on the day of its release. It was perhaps the first beer in Northwest Arkansas to create buzz beyond the local area. Beer traders caught wind and made it a must-get. Ozark has brewed the beer on an annual basis since that first batch. Each edition generates tremendous

Right: There is big demand for Ozark Beer Company's Barrel-Aged Double Cream Stout when it is released each year. *Marty Shutter.*

Below: Ozark Beer Company's new home is located at 109 North Arkansas Avenue in downtown Rogers. *Marty Shutter.*

interest, with lines out the door on the day of its release. The brewery's double IPA is met with similar fervor when it is unveiled each year.

In March 2015, the brewery installed three more thirty-barrel tanks purchased from Karbach Brewing Company in Houston, Texas. The additional fermentation space represented a full 50 percent increase in production capacity and pushed total annual capacity to just over five thousand barrels. In December, Ozark signed a distribution deal with Central and Moon Distributors of Little Rock. The deal paved the way for cans of the APA, Cream Stout and Belgian Golden in Little Rock and the rest of central Arkansas.

Ozark's five-year plan never made it to five years. In fact, it was accomplished in just two. Even with a paced approach, the success was more than Baldwin, Bray and Coates could have imagined when they first started out. All of a sudden, space was an issue. In April 2016, Ozark announced plans to move to a much larger facility at 109 North Arkansas Avenue in Rogers. It was built around 1886 and served as a flourmill during its early existence. The property was most recently a public scales facility. "It just *feels* like a brewery," said Bray on Ozark's blog. "So many people say that when they first walk in." The new location was officially introduced to the public in April 2017—a full year after the move's announcement. The two-story taproom hosted the release of the 2017 version of BDCS a few weeks later. A line of frenzied Ozark fans snaked around the brewery on the day four-packs were finally available for purchase—a testament to the brand's appeal and the prospects for future success at the new location.

Bike Rack Brewing Company (2014)
801 Southeast Eighth Street, Bentonville

For many years, Bentonville was simply an afterthought in Northwest Arkansas. It was the smallest of the region's major cities, and for the most part, it was a sleepy little place that rolled up the sidewalks at sunset. Most people probably think of Bentonville as a corporate town these days. Walmart has called Bentonville home since 1970 (the company opened its first store in nearby Rogers in 1962) and has sat atop the Fortune 500 for several years now. The company has an inescapable presence in Bentonville, and the city has benefited as a result.

Many people move to Bentonville to work for Walmart or one of the numerous suppliers that moved to the area in the 1990s and early 2000s. And the outside influence is readily apparent. As the population expanded the demand for cultural amenities grew. Crystal Bridges Museum of American Art—founded by Walmart heiress Alice Walton—opened in late 2011. Around the same time, several restaurants, coffee shops and beer-centric businesses started appearing as well. Bentonville was all of a sudden on the upswing, thanks in large part to its corporate benefactor.

In a sense, Walmart also played a role in bringing the brewing industry to Bentonville. In 2012, a company intern named Joey Lange was asked to give a presentation on homebrewing to his co-workers. Brewing was a personal passion of his, and by all accounts, he knocked it out of the park. The presentation caught the attention of several seasoned Walmart employees, including Steve Outain (at the time a senior manager in the company's environmental, health and safety department). Outain started homebrewing himself and, before long, was doing it as much as he could. Others found out that he was brewing and soon joined in. The newfound hobby then took on an entrepreneurial tone. Outain partnered with Lange (who had since joined Walmart on a full-time basis), Jeff Charlson, Elizabeth Fretheim and Andy Nielsen to put together Bike Rack Brewing Company.

The fledgling brewery—Benton County's first—found a home at 410 Southwest A Street in Bentonville. Bike Rack was tucked into a small space just south of the downtown square. Joe Zucca, who had experience working at Boulevard Brewing Company in Kansas City, was hired as the first brewer. The brewery consisted of a 3.2-barrel Braumeister system, which utilized a single vessel for the mash, lauter and boil. It was, for all intents and purposes, a giant brew-in-a-bag operation. The brewery consisted of a space not much bigger than a closet, according to Charlson. "It's really labor intensive," he said. "There's nothing efficient about it." Despite those challenges, Bike Rack brewed more than 600 barrels of beer in 2016. It doesn't sound like much, but on a 3.2-barrel system, it's a significant number. Bike Rack's roster of beer included Fast IPA, Slaughter Pen Pale Ale, the Urban Trail Golden Ale, Angus Chute American Stout, Rusty Tricycle Amber Ale and Faster Double IPA.

The team behind Bike Rack sensed an opportunity to add some much-needed experience, and a share of ownership was offered to Ricky Draehn. Draehn had nearly twenty years of experience at Anheuser-Busch and was expected to bring a strong industry perspective to the mix. "We knew we needed a level of knowledge beyond where we were," said Charlson. The

original brewmaster, Joe Zucca, left in May 2016 to open his own place in Cassville, Missouri. Taking his spot were Zach Hickson and Sam Brehm, recent graduates of the University of Arkansas. They kept beer flowing in the taproom and at a few retail accounts around town.

Bike Rack participated in the ScaleUp Ozarks program, which offered a series of classroom and networking events to help grow small businesses. According to Charlson, networking with other business owners was an invaluable experience. Bike Rack was positioned to expand, and the owners were ready to take their operation to the next level. A space in a former Tyson Foods processing plant at 801 Southeast Eighth Street in Bentonville was ultimately selected as the brewery's next location. A part of the new 8th Street Market project, the new space offered plenty of room to grow Bike Rack's capacity. The ten-acre project is also home to the new culinary arts program offered through the Northwest Arkansas Community College. Classes at Brightwater: A Center for the Study of Food commenced in January 2017.

A new location obviously meant an upgraded system was necessary. American Beer Equipment in Lincoln, Nebraska, supplied a new twenty-barrel brewhouse. Also installed were four sixty-barrel fermenters, four twenty-barrel fermenters, one sixty-barrel bright tank and one twenty-barrel bright tank. "We spent time with brewers who used the equipment and designed the whole brewery the way we wanted it," said Charlson. The facility has room for another four or five sixty-barrel fermenters as demand necessitates.

"We had a business plan that was a fantastic work of fiction," mused Charlson. Growth came fast, and expansion happened well ahead of schedule. In January 2017, Bike Rack made another splash when it hired Josiah Moody as the new head brewer. Moody was a respected brewer down in central Arkansas who had made a name for himself at Vino's Brewpub, and through his own beer label Moody Brews. A grand opening event took place at the new location on May 12, 2017. An updated logo and news of canned Urban Trail Golden Ale were unveiled around the same time, adding to the excitement. Charlson said with the bigger brewhouse and Moody at the helm, Bike Rack expects to produce more than two thousand barrels in 2017. The original location on A Street will convert to a pilot brewery and taproom and will remain open for the foreseeable future.

Foster's Pint & Plate (2015)
2001 South Bellview Road #2, Rogers

The brewery with the biggest emphasis on food opened in February 2015 and is located in Rogers. Foster's Pint & Plate is a full-service restaurant that seats 160 in the dining room, with eighty-two taps behind the bar. The five-barrel brewhouse supplies four or more house beers at any given time. The remaining taps represent carefully selected craft beers from the local area and beyond.

The man in charge of the brewhouse is Kyle Brummal, a local flight instructor turned homebrewer. "I started in the garage ten years ago," he said just before Foster's opened. His hobby became an occupation due to a chance encounter in flight school. "I taught the owner [of Foster's] how to fly," he said. "He's giving me a shot at doing this professionally." Brummal's biggest challenge in the beginning was scaling his homebrew recipes up to five barrels. The first beers out of the system were a stout, a double IPA, a pale ale and a beer brewed with caramel apple bread pudding.

The food is outstanding, with an upscale southern cuisine that is both familiar and adventurous. Roasted quail, shrimp and grits and fried chicken and waffles are some of the dining room favorites. Owners Chris and Katie Moore opened Foster's Pint & Plate with solid knowledge of the alcohol

Foster's Pint & Plate opened in February 2015 and is Northwest Arkansas's largest microbrewery restaurant. *Brian Sorensen.*

industry and an entrepreneurial spirit. In addition to Foster's, they own Spiriteaux Wines & Liquors next door to the brewpub, as well as a popular go-cart, bowling and arcade business named Fast Lanes Entertainment, also in Rogers.

Columbus House Brewery and Taproom (2015)
701 West North Street, Fayetteville

Jason Corral and Carey Ashworth are two of the most athletic brewers you'll ever meet. The former lacrosse coaches and avid runners partnered with another slender local named Sam Morgan, and in April 2015, the trio opened a small three-barrel brewery on the edge of the University of Arkansas campus.

It all started in 2010 when Corral received a homebrewing kit as a birthday gift. At first, he struggled with his new hobby, but the biological engineering grad began applying scientific principles he learned in school to improve the beer. Things got remarkably better, and he became obsessed with brewing. Eventually, while toiling as a graduate student, he started to doubt his life's plan. "I realized I didn't want to be doing what I was getting my degree in," he said. "I decided it wasn't worth it, so I started looking for an exit strategy." He and a few friends began working on a brewery project they called Columbus House Brewery. Corral's friends walked away when it became obvious that outside financing was necessary to get the project moving. That's when Ashworth entered the picture. She previously coached the women's lacrosse team at the University of Arkansas with Corral, and the two shared a strong work ethic. They decided that they could get along well as business partners, just as they had done on the playing fields as coaches. So Corral and Ashworth formed a partnership and started working on the plan together.

Columbus House was named for the street Corral lived on as an undergraduate. It was a popular hangout for his friends—the type of place he envisioned his brewery to be. "We always had an open-door policy at our house," he said. "It was a really friendly atmosphere, and that's what I want to try and capture at the brewery." The brewhouse consists of a three-barrel heat exchange recirculated mash system (or HERMS for short). According to Corral, it allows Columbus House to brew with precise mash temperatures and produce crystal-clear beer. The brewery has the feel of comfortable

living quarters. It's not very big, and people often bring their dogs for visits. An outside patio and food trucks cater to patrons during warm weather. Co-owner Sam Morgan built the bar out of three cross sections of red maple and covered it in epoxy. It's an impressive sight to behold.

Regular offerings at the brewery include Yellow Card Golden Ale, Nutty Runner Brown Ale, Weekend Warrior IPA and Spottie Ottie Oatmeal Stout. Kasey Loman, a graphic designer and one of Northwest Arkansas's most prolific homebrewers, designed several logos for Columbus House. Her work is clean and colorful and represents the spirit behind each beer.

Columbus House has a strong association with health and physical well-being. The brewery has sponsored a number of running events, and even offers yoga in the taproom from time to time. The Razorback Regional Greenway trail system crosses North Street just below the brewery and the city's oldest park—Wilson Park—is not far away. The owners are young and lithe, and fortunately, every athletic endeavor at the brewery ends with a beer.

Bentonville Brewing Company (2015)
1700 South First Street, Rogers

Lee Robinson was looking for a brewer when he heard that his boyhood friend from Mississippi was living in Colorado and had caught the homebrewing bug. So he called Beau Boykin and offered him a job in Arkansas. Boykin jumped at the chance, and in June 2015, they opened Bentonville Brewing Company together.

The pair weren't the only people involved in the project. Robinson, who worked as a loan officer, initially recruited local real estate agent Gavin Edwards to work on the brewery concept with him. They now serve as the brewery's managing partners. Boykin's wife, Katie, accompanied him to Bentonville. She is, in many ways, the face of the brewery, handling administrative and marketing duties. The Boykins also have an ownership stake in the brewery.

Beau Boykin had a background in biology prior to moving to Arkansas, but before moving for the job at Bentonville Brewing Company, he had only brewed at home. A seven-barrel direct-fire brewhouse was soon his domain—a big step up in scale. Bentonville Brewing Company ferments in two seven-barrel fermenters and a few fourteen-barrel fermenters. Some of the first beers Boykin produced at the brewery were City Slicker Amber Ale,

Bentonville Brewing Company co-owner Katie Boykin poses behind the bar shortly before the brewery opened in 2015. *Brian Sorensen.*

Naked Porter, Homewrecker IPA, West Fork Witbier and N.W.A.P.A. (a pale ale). Airship Coffee, Bentonville Brewing Company's next-door neighbor, supplied beans for a beer dubbed Airship Coffee IPA. Perhaps the most talked-about beer from the young brewery has thus far been Salted Cherry Sour, a take on the traditional German-style Gose beer. Tart cherries lent a subtle sweetness to balance the acidity of that particular beer. Its bright pink hue made it stand out among more common yellow, brown and black beers found in the market.

Bentonville Brewing Company was originally located south of the Bentonville's downtown square in a renovated warehouse space. "Right now when people come to the taproom they are surprised that we brew

in that little space," said Katie Boykin. Long wooden tables extended the length of the taproom, providing highly communal seating that fostered conversations between friends and strangers alike. According to Katie Boykin, who wears the title of COO, the brewery has seen a 20 percent increase in production since it opened and now has more than seventy tap accounts throughout the region. Bentonville Brewing Company produced 650 barrels of beer in 2016.

Expansion is something the brewery is prepared for. A fifteen-barrel fermenter was installed in October 2016 to increase capacity, and a bottling machine was purchased from a brewery in Oklahoma. There are plans to build a new brewery at an undetermined location soon. A twenty-barrel brewhouse is the goal, along with a new canning line. May 2017 brought word that Bentonville Brewing Company was moving into Ozark Beer Company's old space at 1700 South First Street in Rogers. According to Katie Boykin, the brewery will keep its name, even though it will be one town removed from its namesake.

BLACK APPLE CROSSING (2015)
321 East Emma Avenue, Springdale

Black Apple Crossing isn't a brewery. But it is—as far as anyone can tell—the state's first hard cidery. As closely linked as beer and cider are these days, it stands to reason that Black Apple should be included in a book celebrating Arkansas's brewing industry.

Long before Northwest Arkansas became known as ground zero for American chicken production, apple orchards covered the landscape. In the late nineteenth and early twentieth centuries, there were several businesses in the area that catered to the apple industry. The Kimmons, Walker & Company plant—the region's largest evaporator—was located in the heart of Springdale. The industry eventually declined due to disease and insect infestation. Lost in time was the significance apples once had for the economy of Northwest Arkansas, and for Springdale in particular.

The city returned to its roots when partners John Handley, Trey Holt and Leo Orpin opened Black Apple Crossing in downtown Springdale in July 2015. The trio purchased an old building that was long ago home to a hatchery and office space operated by poultry producer George's. The three partners tore into the plaster, dirt and grime that accumulated over

the decades and found structural elements that were worth saving. "We love the open rafter look," said Orpin, referring to the ceiling above the production floor. Brick walls and dark wood give the taproom a historic look.

Orpin knew a thing or two about the alcohol industry. He previously worked for Arkansas Craft Distributors, a relatively new distributor with a focus on craft beer. Arkansas Craft was responsible for bringing some of the nation's top breweries into the state, including Bell's, Oskar Blues and Stone. Orpin knew full well that the beer industry was exploding, and he thought there was space for locally produced cider, too. Handley and Holt had backgrounds in microbiology, both working in a lab for a major food producer in Springdale. While Orpin focused on running the business, Handley and Holt were slated to handle production and quality assurance.

Springdale's Black Apple Crossing has reintroduced apples to a region that was once famous for them. *Brian Sorensen.*

Black Apple Crossing is located near the Arkansas & Missouri Railroad headquarters and is smack dab in the middle of Springdale's downtown revitalization efforts. Nightclub & Bar Media Group named it one of 2015's "Top Rated New Hot Spots." For people growing bored with local beer, cider can be a welcome respite from barley and hops. And for those who only know commercial ciders, Black Apple's offerings are different. "We're aiming for balance," said Orpin. "Most of the commercial ciders out right now—Angry Orchard, Wood Chuck—are very sweet. We want to do a semi-dry, semi-sweet cider that's easy to drink." Among Black Apple's regular offerings are Dry Guy (7.8 percent ABV), Ozark Dry (6.8 percent) and El Cariño (7.8 percent). They range from crisp and dry to semi-sweet. Seasonal variations with fruit and spices can be found on tap most of the time as well. "There are a lot of cool ways you can play around with cider," said Orpin.

New Province Brewing Company (2016)
1310 West Hudson Road, Rogers

Derek McEnroe worked for MillerCoors as a sales analyst. The Arizona native moved to Northwest Arkansas for college, and after graduating with a degree in information systems, he found himself stuck in the corporate rat race. Although MillerCoors is often thought of as the enemy of local and independent brewers, the company actually sparked McEnroe's interest in craft beer. MillerCoors openly encouraged its employees to try beers outside the company's portfolio so they could better understand the market. McEnroe eagerly took his employer up on the challenge. His curiosity in beer flavors led to homebrewing in 2011. "I started like everybody—with an extract beer kit," he said. It wasn't long before he transitioned to an all-grain setup. McEnroe was obsessed with Ray Daniels's book *Designing Great Beers* and brewed as much as he could. With only a few years of homebrewing experience under his belt, and like so many before him, he started thinking about taking his hobby to the next level.

Approaching his wife, Megan (who had her own career in information systems), with the idea was something McEnroe carefully considered. He discussed the brewery concept with several friends before mentioning it to her. To his surprise, it was an easy sell. Megan McEnroe was a fan of craft beer, too, and she saw the awesome opportunity it presented. She encouraged her husband to get things moving as quickly as possible. "If we didn't do it we would regret not trying," Derek remembered of their thought process at the time. "If we did it and failed miserably, we wouldn't regret it, because at least we tried something." In December 2014, he quit his job and put all of his energy into the brewery project. The name, New Province Brewing Company, was a reference to a new era in Benton County. "It's a conceptualization of what the area has become over time," he said. "Especially with the area going wet. It's a different mindset now."

Unlike most breweries in the state, New Province Brewing Company is in a newly constructed facility instead of a retrofitted, preexisting space. "We had a spot we really wanted to go in downtown Bentonville," said Derek McEnroe. "But the deal didn't work out and…we were left scrambling to find a new location because the brewing equipment was already on the way." Megan McEnroe found a warehouse on Hudson Road in north Rogers that looked like a potential fit. It was already under contract, but the builder said he could custom-build one for the McEnroes instead.

Derek McEnroe once worked for one of the world's biggest brewers as a sales analyst. Now he owns New Province Brewing Company in Rogers. *Brian Sorensen.*

The 8,100-square-foot warehouse was built with brewery specifications in mind. Drains were laid in the proper places, and a loading dock was put in the perfect spot for deliveries. A fifteen-barrel brewhouse from Deutsche Beverage Technologies in Charlotte, North Carolina, was installed. "It's all custom stuff," said Derek McEnroe. "We went through all the design

process with them and identified all the things we wanted." Fermentation duties were assigned to four thirty-barrel fermenters. A thirty-barrel bright tank was also put in place. An enormous amount of space was left for future expansion.

The taproom occupies approximately one-fourth of the building. It features large picture windows that provide a clear view into the brewery. New Province was met with plenty of enthusiasm from the local beer community when the doors opened in January 2016. The taproom saw steady business from the start, and New Province established its brand through key retail accounts. Year-round beers were established early and included Civilian Pale Ale, Philosopher IPA, Migrant Belgian Dubbel and Yeoman Porter.

In October 2015, Kort Castleberry was named head brewer at New Province. It was time for Derek McEnroe to focus more of his attention on the business, and the former Fossil Cove assistant seemed like a good fit. "My perspective as a brewer is to always do something fun or a little bit different," said Castleberry. New Province continually plays with ingredients and recipes, producing beers like Chile Pepper Yeoman and Greed & Gluttony (an oatmeal stout with Belgian candy sugar). Packaged beer was announced in May 2017, with the can for Fallen Queen Belgian Style Witbier introduced via social media. BLKBOXLabs, which lent a creative hand to fellow breweries Ozark Beer Company and Fossil Cove Brewing Company, was behind the effort. "The overall goal with this can is to breathe more life into our brand," said Derek McEnroe.

LITTLE ROCK BREWERS

Little Rock is located in the center of Arkansas, at a point where three distinguishable land formations come together. The mountains of upland Arkansas extend to the north and west, the lowland Delta reaches east toward Mississippi and gentle rolling hills are found to the southwest. Little Rock's centralized location made it a natural hub for culture and commerce in its early days, beginning well before it was established as the territorial capital of Arkansas in 1821. It officially became a city when incorporated a decade later. Arkansas joined the United States as the twenty-fifth state in 1836. The importance and power of Little Rock increased along the way.

To define Little Rock's culture is difficult due to the diversity that lives within the city limits. For decades it was the only true metropolitan area of the state. Outsiders came in waves to stake their claim in the bustling frontier town. They came from places like Ireland, Germany and Scotland, but also from northern states looking for economic opportunity and a warmer climate. The oldest newspaper west of the Mississippi River, the *Arkansas Gazette*, was founded in 1819. Little Rock seemed to be on the cutting edge of westward expansion.

Little Rock has experienced rapid growth since its incorporation. At the turn of the twentieth century, it was home to just under 40,000 people; by 1950, that number had grown to 100,000-plus. The most recent census numbers show nearly 200,000, with almost equal parts white and black and another 9 percent or so who claim Hispanic heritage. It's an incredibly diverse

place, and although it has experienced troubled times at different points in its long history, a vibrant revitalization of culture, art and humanities has helped Little Rock exemplify urban renewal in the American South. The return of the brewing industry—which was humming prior to Prohibition—has played a key role in Little Rock's resurgence.

Bosco's (2003–14)

Bosco's was a brewpub chain based in Memphis, Tennessee. It was founded by Jerry Feinstone and Chuck Skypeck in 1992. Feinstone was a stockbroker, and Skypeck worked as a store manager for Walgreens. A longtime homebrewer, Skypeck often thought becoming a professional brewer. When the Tennessee legislature permitted brewpubs in 1992, he jumped at the chance to get into the business. Bosco's Pizza Kitchen & Brewery opened in Germantown, Tennessee, in December of that year. In 1996, a location in Nashville launched. At its peak, Bosco's operated four regional locations, including Little Rock, which took over the old River Rock Brewing Company location in the River Market area of downtown.

The Little Rock location was much like the others in the chain. Its menu featured oven-fired pizzas and calzones, as well as several house beers on tap. Four were year-round—Downtown Brown, Isle of Skye Scottish, Bombay IPA and Flaming Stone—and four rotated regularly. One of the most notable brewers on staff was Will Gallaspy, who would go on to brew at Parish Brewing Company in Louisiana and West Mountain Brewing Company in Fayetteville.

In April 2009, Josh Quattlebaum was hired as a server. Just twenty years old, he noticed what was happening in the brewhouse and took an immediate interest. When Gallaspy announced he was leaving, Quattlebaum was offered a chance to brew. "I started brewing in August 2011," said Quattlebaum. "Will [Gallaspy] trained me before he left. His motto was 'a clean beer is a good beer.'" Quattlebaum went on to win a gold medal at the 2012 World Beer Cup while brewing at Bosco's. "It was the first beer I brewed by myself," he said, referring to the hefeweizen that won him the accolade.

Bosco's was a fixture in downtown Little Rock, and it came as quite a surprise when its closure was announced. The Franklin and Nashville locations were also shuttered, leaving Memphis as Bosco's only brewpub still in operation. Ghost River Brewing Company—a Memphis brewery

founded by Feinstone and Skypeck in 2007—had increased its capacity around that time, which might have led to the consolidation of efforts that caused Bosco's sudden retraction.

Bosco's had an impact on the Arkansas beer scene in its decade of operation. It rescued a location that had met a quick and decisive demise (River Rock) and proved that a brewery or brewpub could have sustained success in Little Rock. "Up to that point it wasn't as big of a scene," said Quattlebaum. "There were only three breweries in the city when Bosco's opened." Thing changed significantly in the years that followed.

Refined Ale (2010)
2221 South Cedar Street, Little Rock

Windell Gray is the first African American owner and operator of a brewery in Arkansas. His is located just blocks from historic Central High School, the site of the Little Rock desegregation crisis of 1957. Then governor Orval Faubus attempted to block the integration of nine African American students into the school. Like much of the South in those days, Little Rock was a tinderbox, ready to explode. President Dwight D. Eisenhower ultimately federalized the Arkansas National Guard and commanded the troops to ensure a peaceful integration. Fifty-three years later—in April 2010—Gray served a helping heap of poetic justice by opening his brewery in the shadows of Central High.

Gray was born in California but moved to Arkansas when he was just two years old. His grandfather lived in east Texas and was a major influence in his life. He owned a still and used liquor to barter for goods and services in the small town of Groveton. Over time he taught all of his sons the fine art of whiskey distilling. Since they never had sons of their own, the next to learn the family tradition was Gray. Although he eventually became quite adept at brewing and distilling himself, he swore off alcohol and to this day doesn't drink. His uncles often took their own drinking too far, and that left an impression on Gray that has lasted a lifetime.

In 1991, Gray opened a barbecue restaurant called Mr. G's in his hometown of Little Rock. The restaurant was extremely popular with locals, but perhaps more importantly, it's where Gray started to dabble with fermented beverages. Some of his homemade wine made its way into the sauces for various dishes, and he started brewing beer as well. Gray eventually

closed the restaurant and drove a semi to earn a living. An economic recession set in, and by 1998, he was forced to make another tough career decision. At that time, Gray's mother owned and operated a popular Little Rock restaurant called Wayne's Fish & Burgers to Go. For a while she also ran a hair salon in the other half of the building. Somehow, he convinced her to donate the salon space to start a brewery. Financing was difficult to obtain, however. Despite approaching multiple Little Rock bankers with his idea, Gray kept coming up empty. "Everybody I talked to said no," he said. So, with a meager $40,000 investment, he opened Refined Ale Brewery on his own.

Refined Ale's Windell Gray. *Steve Shuler/Rock City Eats.*

The workhorse of the brewery is a three-barrel system that was manufactured in nearby Cabot, Arkansas. Gray is the lone employee at Refined Ale, where he brews exclusively with malt extract. Because he doesn't drink himself, he relies on friends and family to provide feedback on his recipes. Beers from Refined Ale include Golden Light Beer, Imperial Pale Ale and Irish Style Stout—which is the brewery's best seller. Gray also produces a malt liquor product.

In the early stages of the brewery, Gray worked with a distributor to get his beer into the Little Rock market. He was unhappy with the arrangement, so a year after opening the brewery, he made the decision to self-distribute. This was, of course, a tall order for a one-man operation. Gray has recently reined in distribution and sells his beer exclusively at the brewery. Things have been working out fine since he made the move. Many patrons will pick up some spicy soul food from his mother's restaurant—which still operates next door—and then stop by the brewery for some beer.

Griffin is passionate about his brewery. It should be noted that he's somewhat unconventional when it comes to the brewing process. "Once it comes out of the fermenter we run it back to the kettle and boil it again," he said unapologetically. This double-brew method is a bit of a mystery to some, but for others it's the reason they drink Gray's beer. It's different from the rest. And given the brewery's location—tucked into a neighborhood that has seen its fair share of change—it seems appropriate that Gray would blaze his own trail.

Flyway Brewing (2012)
314 Maple Street, North Little Rock

The story of Flyway Brewing Company doesn't start in North Little Rock, where the brewery is currently located. Nor does it begin across the river in the capital city, where the idea first took flight. No, the catalyst for Flyway took place in North Carolina. That's where Matt Foster and Jess McMullen forged a friendship that would one day lead them both to Arkansas.

The two met in 1992 at a small liberal arts college about thirty minutes outside Asheville. McMullen was a few years older and served as Foster's resident assistant in the dorms. While there, McMullen majored in religion, with plans to one day become a clergyman. Those plans shifted as his worldview came into focus and his priorities changed. He dropped out of school for a few years to regroup. McMullen later returned to college to finish his degree and afterward worked in the Asheville bar and restaurant industry. Upon graduating with a degree in biology, Foster moved to Russellville, Arkansas, to study English at Arkansas Tech University. He eventually found his way to Little Rock to teach at historic Central High School.

Foster and McMullen stayed in close contact throughout the years and eventually started trading beer through the mail. They were really getting into craft beer and appreciated the access to each other's beer market. Foster brewed a Sam Adams clone for a friend's bachelor party and officially became a homebrewer. He was quickly hooked on the pastime and brewed as much as possible. He sent McMullen his own beer instead of commercial beer during trades. The first mention of opening a brewery together happened in March 2011 during a spring break outing in the mountains surrounding Asheville. "We were doing something we called 'spring break for life' back then," said McMullen. The annual event allowed old college friends to spend time together and keep their connections alive. Foster, McMullen and a few others kicked the idea around that night. It wasn't long before the idea gained traction.

Back in Little Rock, Foster started applying for permits to become a commercial brewer. He purchased a half-barrel SABCO system in 2012 and established the newly christened Flyway Brewing Company in the basement of Quapaw Towers. He shared space with Loblolly Creamery, another upstart Little Rock business. In the beginning, Foster tweaked his recipes and brewed small batches. He hauled kegs of beer around town and poured samples at charity events and beer festivals. Foster struck a deal with restaurant South by Main to feature his beer. Flyway was making a name for

itself without the benefit of a large brewery and taproom. Foster recruited McMullen to help take the brewery to the next level. McMullen agreed and started the process of moving his family from North Carolina to central Arkansas.

In 2015, Flyway attended the Hot Springs Craft Beer Festival and turned a few heads. Pick-a-Pepper Pale Ale garnered attention with big additions of poblano peppers. The beer lacked heat, with most of the pepper character in the aroma. Many breweries were in attendance that day, but Flyway stood out with its unique offering.

By the time the brewery was ready to settle into a permanent location, there were several options on the table. Flyway lost a few—including one in the area that Rebel Kettle and Lost Forty now call home—before it settled

Co-owner Jess McMullen serves Pick-a-Pepper Pale Ale at the 2015 Hot Springs Craft Beer Festival. *Brian Sorensen.*

on North Little Rock as home base. The brewery opened in December 2015 in the Argenta District, which is also home to Diamond Bear Brewing Company and a satellite taproom of Core Brewing Company. "We have a good-sized building," said McMullen. "It's 5,500 square feet, with another 1,000 square feet in the back for growth." The brewery holds a ten-barrel brewhouse, with one thirty-barrel and four ten-barrel fermenters. The goal is to grow production slowly and responsibly. Another thirty-barrel fermenter was announced in May 2017.

McMullen is in charge of the brewhouse. Now that the brewery is up and running, Foster has returned to teaching full time. One of his former English students at Central High, Tim Berkley, is a partner and helps with the brewing duties. Ryan Frank was hired away from Pisgah Brewing Company in Black Mountain, North Carolina, recently—coincidentally, Foster taught his wife in high school before she moved to North Carolina for college. The connections are strong at Flyway, which was named in reference to the bird migration route that extends from Canada down through the Mississippi River Delta. The theme influenced the names of the beers: Early Bird IPA, Free Range Brown Ale, Migrant Pale Ale and Shadowhands Stout.

Most of the distribution has thus far been through draft accounts, although Flyway has also made limited runs of twenty-two-ounce bottles. According to McMullen, Bluewing Berry Wheat is Flyway's top-selling beer. It was originally brewed as a seasonal offering but was extremely popular when served at Arkansas Travelers games across the street from the brewery. Several other accounts asked Flyway to keep the beer year-round, and so it became a part of the permanent portfolio. Bluewing is an American wheat that has a big blueberry muffin aroma. Flyway uses organic blueberry puree to flavor the beer after fermentation. It is subtly tart without much sweetness, and it appeals to even the biggest fruit beer dissenters. McMullen said it will be the first beer canned by Flyway—set to happen sometime in 2017.

McMullen noted that the food scene in Little Rock was a solid precursor to the city's recent surge in brewing. There were a handful of reputable chefs moving into town, and people were starting to prioritize a total culinary experience instead of commodity-style eating. The brewery prides itself on an attention to detail and has found ways to develop the same characteristic in its employees. Flyway recently announced an employee-brewing program that gets front-of-the-house employees involved with the brewing process. The small-batch beers produced by employees will be featured exclusively in the taproom. For a brewery that started out making small batches, the program helps connect Flyway's past with its present.

Stone's Throw Brewing (2013)
402 East Ninth Street, Little Rock

Homebrewers dream of becoming professional brewers. It's pretty much a universal truth. And Little Rock homebrewers were never an exception to that rule, even though the city seemed to trail other brewing communities in terms of commercial action. Little Rock was, in fact, always full of homebrewers, and they all dreamed of going pro one day. In 2013, four members of the local homebrewing club—the Central Arkansas Fermenters—made their personal dreams come true by joining forces and opening Stone's Throw Brewing.

Ian Beard is the most recognizable of the foursome, mostly because he's an outgoing guy and the co-owner who takes most of the interview requests. He hails from Fayetteville, Arkansas, but went to school at Hendrix College in Conway (where he studied political science). It was there—in a dry county—that he received a homebrewing kit for his twenty-second birthday. After his time at Hendrix, Beard moved to Little Rock to work at Old State House Museum as a living historian. He's not the only member of Stone's Throw with an interesting background. Brad McLaurin is an architect, Shawn Tobin is a private investigator and Theron Cash—who does most of the brewing—is a pilot by trade.

After agreeing to become partners, the foursome settled on a location in Little Rock's MacArthur Park Historic District. Bounded by Capitol, Scott, Fifteenth and Interstate 30, the neighborhood was Little Rock's first to be listed in the National Register. The area is full of historical significance and is the namesake of MacArthur Park—the oldest municipal park in the city. The park was itself named for General Douglas MacArthur. He was born on the property, which was then a military arsenal, in 1880. Ten years later, the United States Department of War traded the arsenal to the city of Little Rock for one thousand acres on Big Rock Mountain (now home to a VA hospital).

The history of the building Stone's Throw occupies in the neighborhood is also quite interesting. Jean-Pierre Fougerousse built the existing structure in 1910 and operated Little Rock Bakery there with his family. Later businesses at the location included an auto garage, a shoemaking business and a drugstore. Baker's Liquor operated there until the late 1990s.

The guys behind Stone's Throw did most of the renovation work themselves. There was a tremendous amount of demolition involved to get the place ready for improvements, so it took time to complete the work.

At times, the team felt like throwing up its collective hands and calling it quits. They couldn't find the sewer lines, for example, and they didn't know where the toilets led. The building was old and really showing its age. Eventually, it was stripped to bare studs, and the brewery started to take shape.

A crowdfunding campaign was set in motion in April 2013 to raise funds for the taproom. The vision for the space was robust, as highlighted on the Kickstarter website:

> *We would like to turn this space into a great neighborhood watering hole where we can serve our fresh made beer to the masses. We need to build a bar; purchase tables, chairs, and stools; install a keg cooler and tap wall; and make the space respectable by painting, replacing lighting, repairing the floor, and renovating the existing bathroom to meet ADA requirements. We have big ideas for this place, friends: gallery space, food trucks, game nights, beer dinners, local tapas and special events, but we need your help making this beertopia a reality. The four of us are trying to live very homebrewer's dream with the creation of Stone's Throw Brewing, and we want you to be a part of it!*

People who contributed $10 received a Stone's Throw sticker. Those who donated $100 or more were promised one of the brewery's first pours. $2,000-plus earned donors the opportunity to brew with the owners on the Stone's Throw brewhouse. The crowdfunding campaign was wildly successful, with $10,000 raised in just three and a half days. In total, the brewery was able to raise more than $20,000 from its supporters.

Stone's Throw began brewing on its three-barrel system in July 2013 and opened the taproom a month later. The first beer brewed was Shamus Stout, which was based on a homebrew recipe. The first batch resulted in a much higher ABV than intended, but was no less enjoyable. That version of Shamus Stout—an imperial stout—is brewed each year to celebrate the brewery's anniversary. The lower-ABV version continues to be one of Stone's Throw's most popular offerings. Other beers brewed in those first few batches were Rene Descartes Dunkelweizen, SGP ESB and Two-Timing American IPA. Stone's Throw was intent on taking an artisanal approach to brewing, with an emphasis on interesting styles and quality ingredients.

Like many small breweries, Stone's Throw expanded quickly. It doubled capacity toward the end of 2013 with two new three-barrel fermenters. In March 2016, the brewery spread into the "annex," a formerly separate

The fermenters inside Stone's Throw Brewing. *Brian Sorensen.*

storefront adjacent to the taproom. Somewhat timid based on their previous renovation experience, the brewery's co-owners weren't sure how to proceed with the project next door. "We had all agreed that we weren't going to go through all the trouble we went through to renovate our original space before we opened," said partner Theron Cash in a press release. "But after seeing a couple of estimates of what it would cost to hire the work out, I said that on second thought we could get it done a lot cheaper if we just did it ourselves again. So that's what we did." Barn doors were used to facilitate movement between the two spaces. The annex received a red oak bar of its own, along with a new cooler to accommodate six taps.

Stone's Throw wanted to be a neighborhood brewery, and that's exactly the niche it fills in the Little Rock market. The taps constantly rotate with such notables as Jean-Claude Van Damme (a Belgian strong ale), Dunbar Wit, Aurora Borealis (a Scottish ale) and Dark Helmet (a schwarzbier). Year-round offerings include Amadeus Vienna Lager, Shamus Stout and Heritage Weizenbock.

Blue Canoe Brewing Company (2014)
425 East Third Street, Little Rock

Crowdfunding was the catalyst for another Little Rock brewery. Patrick and Ida Cowan teamed up with Laura Berryhill to open Blue Canoe Brewing Company in December 2014 after raising $18,455 from online investors.

Berryhill and Ida Cowan became become friends while working at a local hospital. Berryhill was a surgical assistant at Arkansas Bone and Joint Orthopedic Surgery, and Ida Cowan was a doctor at Saline Memorial Hospital. They shared similar interests and started spending time together. It wasn't long before Berryhill's love of beer was apparent. She grew up brewing beer with her father and grandfather and talked about it often. Patrick Cowan—Ida Cowan's husband—was a local attorney with Clark Mason Attorneys and also a homebrewer. Brewing together was inevitable once they met. As stated on the brewery's website, "As Laura and Patrick continued to brew together, the inevitable talks of 'wouldn't it be great to have our own brewery' sprung up."

Blue Canoe Brewing Company was chosen for the brewery's name because the owners were into canoeing and paddling. While brewing in Berryhill's garage one day, they looked up and saw her blue canoe hanging from the ceiling. The name Blue Canoe seemed like a natural fit because of the popularity of outdoor activities in Arkansas.

A Kickstarter campaign was launched in September 2014. Blue Canoe quickly exceeded its original goal and subsequently set a stretch goal of $17,375 (which it also surpassed). The additional money was intended to pay for glycol jackets for the fermenters and bright tank. Blue Canoe "backers" received various gifts based on giving levels—coasters, T-shirts, mugs and so on. The necessary funding was obtained in less than a month, demonstrating how receptive Little Rock was becoming to the notion of locally produced beer.

Setting up the brewery was a challenge for the first-time brewers. In several interviews, they admitted that they learned a lot through the process, including some tough lessons. The brewhouse includes a three-barrel system that is tucked into a relatively small space (eight

The name for Blue Canoe Brewing Company was inspired by a canoe hanging from co-owner Laura Berryhill's garage ceiling. *Blue Canoe Brewing Company.*

hundred square feet with seating for about twenty). Tin and wood trim the taproom, which is next door to popular downtown breakfast spot Andina Café and a short walk from the Little Rock River Market. Visitors staying at the downtown Hampton Inn will find the brewery right around the corner and highly convenient for pre-dinner drinks or a nightcap. Popular beers at Blue Canoe include Razorback RyePA, Whittler Milk Stout and Paddler American Wheat.

Blue Canoe produced 175 barrels in 2015, its first full year of production. In April 2016, Blue Canoe opened a restaurant next door to the taproom that it named, simply enough, Taco Beer Burrito. It featured a separate entrance and sixteen taps to go along with a Tex-Mex menu. The 1,500-square-foot space closed the following December and was slated to become an extension of the taproom. Production increased to nearly 350 barrels in 2016. Blue Canoe Brewing Company may look to expand production further in the near future but is thus far comfortable with its status as a nanobrewery.

Lost Forty Brewing (2014)
501 Byrd Street, Little Rock

Yellow Rocket Concepts is a powerhouse Little Rock restaurant group. It operates Big Orange, Local Lime and Zaza—popular eateries and places to grab a stiff drink in the city. Principal partners in Yellow Rocket are John Beachboard, Scott McGehee and Russ McDonough. Their company is a big player in the Little Rock food scene. The concepts are on trend, and Little Rock residents seem to enjoy spending their money there. As craft beer became more and more popular, it was inevitable that Yellow Rocket would take a stab at that, too.

Past success led to a strong start for their brewery. Beachboard, a Hendrix College graduate, and McGehee, the founder of Little Rock's Boulevard Bread, both possessed extensive backgrounds in restaurants. McDonough brought a business perspective picked up in the publishing and real estate industries. Beachboard's wife, Amber Brewer, whose career included a stint as an art director in the advertising industry, plays a role on the team as well. She is Yellow Rocket's creative director and has an eye for all things aesthetic, including in-restaurant design and brand marketing.

The team chemistry was undeniable in the early days. Yellow Rocket's restaurants brought in nearly $12 million in sales in 2014. Sensing an

Lost Forty Brewing Company is located at 501 Byrd Street in Little Rock. *Brian Sorensen.*

absence of production breweries in the market, the group started eyeing a brewery startup. Yellow Rocket added partner Albert Braunfisch, CEO of Mail South Inc., and started to build Lost Forty Brewing Company. Their concept for Lost Forty—which was named for a stand of virgin timber in nearby Calhoun County—included a strong brand image coupled with large-volume production capabilities.

A twenty-thousand-square-foot warehouse—once home to Candy Bouquet—was leased just east of I-30 near downtown Little Rock. Omar Castrellon was hired as head brewer, and Lost Forty launched with a 30-barrel brewhouse and a 150-barrel fermenter in December 2014. Castrellon came to the brewery via Thr3e Wise Men in Indianapolis, where he was the head brewer, and helped with startup. He was no stranger to Little Rock, of course, having brewed for several years at River Rock Brewing Company (and later Chit's and Castaway Island). In fact, Castrellon can credit a connection from those early days of Little Rock brewing for helping him land the job at Lost Forty. Bill Riffle—his former assistant at River Rock—was originally in discussions with Lost Forty about the job. Riffle was committed to the brewery that he co-owns with his wife, Tony Guinn, in Big Flat, Arkansas, so Riffle recommended Castrellon for the job instead.

Lost Forty came out of the gate strong. The brewery was big, and the taproom was impressively large as well. The old warehouse was fully renovated and featured one-hundred-year-old reclaimed windows and pipework around the ceiling. Brewer had a huge role in creating the space, and what resulted was a taproom with an abundance of industrial character. Long wooden tables serve as communal gathering places and there's plenty of room to spread out.

Lost Forty added two 90-barrel fermenters and two 90-barrel bright tanks in March 2015. Cans were rolled out right away, with Bare Bones Pilsner, Lost Forty Pale Ale, Love Honey Bock and Rock Hound IPA available throughout most of Arkansas. In the first full year of operation, Lost Forty brewed 4,650 barrels. It finished 2016 at over 10,000 barrels, making it one of the top brewers in the state by volume. All of this was accomplished in less than two years' time—an amazing accomplishment of scale. Two 240-barrel fermenters and a 240-barrel bright tank were installed in 2017, positioning Lost Forty as a dominant brewing force in Arkansas for the foreseeable future.

Moody Brews (2014)
Various Locations (Contract Brewer)

Josiah Moody is an Oklahoma native by way of several Arkansas towns. He lived in Greenland, Arkansas, as a young boy before moving to Hampton in the far lower reaches of the state. He graduated high school in Hot Springs and eventually landed in Little Rock. Over that stretch of relocations, he started (and stopped) pursuing a career in medicine and subsequently built a reputation as one of the best brewers in the state.

Moody's first professional foray in brewing was at venerable Little Rock brewpub Vino's, which opened in 1991 and started brewing onsite two years later. Brewer Bill Riffle helped put Vino's on the map with a few medals from the Great American Beer Festival. When Moody came on board as head brewer, he was a relative unknown. Over the next three years, he helped Vino's recapture some of its former glory.

In 2014, Moody announced that he was starting his own label—Moody Brews—and was leaving Vino's. He partnered with Choc Beer Company in Krebs, Oklahoma, to brew and package his beer. An imperial IPA called Half Seas Over and a dark Belgian known as Sixes and Sevens both hit the

Josiah Moody brews with watermelon inside Vino's Brewpub. *Moody Brews.*

market in four-packs of twelve-ounce bottles. Available in the Little Rock and Northwest Arkansas markets, the beer received accolades from everyday beer drinkers and beer critics alike.

In November 2014, Moody collaborated with Apple Blossom Brewing Company in Fayetteville to brew Earl Grey ESB. The beer sold quickly, and Moody's reputation continued to grow. After some contractual issues with Choc developed, Moody took his brewing skills to Damgoode Pies, which was in the process of taking over the closed Bosco's location in Little Rock's River Market. He helped Damgoode brewers Josh Quattlebaum and Nick Dudley tweak some recipes for the new operation, and in exchange, Moody was able to brew a few batches there under the Moody Brews name. One of the best was Cuban Pull, a coffee-infused brown ale that many consider to be his best beer to date.

Throughout his career, Moody has been known for incorporating cask conditioning, fruits, herbs, peppers and wild yeast into his beers. Dunbar Garden, a community garden effort in downtown Little Rock, has contributed many ingredients for his recipes. Moody returned to Vino's in late 2015 and brewed several batches of beer utilizing ingredients from Dunbar, including a farmhouse ale made with fifty pounds of pluots (an apricot-plum hybrid). In October 2016, Vino's featured Cuban Pull Imperiale—the rum barrel–aged version of the popular beer that weighed in at a hefty 10.4 percent ABV.

In January 2017, Moody shocked the Arkansas brewing community by announcing that he was taking the head brewing position at Bentonville's Bike Rack Brewing Company. The brewery was slated to move into a new seven-thousand-square-foot brewing facility and increase production with a new twenty-barrel brewhouse in early 2017. Moody said that he hoped to keep brewing beer under the Moody Brews flag as time allows.

Damgoode Brews (2015)
500 President Clinton Avenue, Little Rock

When Bosco's closed its River Market location, it left a huge gap in the local brewing scene. The prime real estate location housed several iterations of breweries dating as far back as 1997, when it opened as River Rock Brewing Company. It was a relief for many Little Rock beer drinkers when Jeff Trine announced that he was taking over the location with another edition of his popular pizzeria Damgoode Pies. He purchased the turnkey brewing system and inherited Bosco's head brewer, Josh Quattlebaum, in the process.

The River Market location was the fourth in the Damgoode Pies chain, which opened its first at 2701 Kavanaugh Boulevard in Little Rock in 2001. The food was extremely popular in Little Rock. In September 2011, *Food Network* magazine named Damgoode's Stuffy Underdog pizza the best in Arkansas. Formerly known as the Mexicali, the pie featured hamburger, peppers, onions, black olives and a heavy layer of pink sauce on top of cheddar cheese. The restaurant later expanded into Northwest Arkansas with locations in both Rogers and Fayetteville. Pizza-by-the-slice made Damgoode a popular lunchtime destination in each of those cities.

When Damgoode took over its new brewhouse, Quattlebaum had plenty of working knowledge of the seven-barrel system. Nick Dudley, a former homebrewer and associate of Trine's, was hired to assist. Damgoode initially struck a deal with Josiah Moody of Moody Brews to help with the transition, as well as to occasionally brew under his own label. Moody helped tweak the recipes for Pale Ale and Red Ribbon (a golden ale) right away. After Moody departed for Vino's (his second stint at Little Rock's original brewpub), recipe development responsibilities shifted to Quattlebaum, who relished the opportunity to flex his creative muscles. While at Bosco's, he was relegated to using the chain's in-house recipes, so he was excited for the chance to make his own mark.

Quattlebaum is somewhat of an anomaly in the brewing industry in that he didn't start as a homebrewer and never really took up the hobby. He did have the good fortune to take a three-and-a-half-month sabbatical in 2016 to visit several breweries out west. One of those breweries was New Belgium Brewing Company in Fort Collins, Colorado. It was New Belgium's Fat Tire, in fact, that served as the inspiration for one of the beers Quattlebaum is most proud to have brewed: the Arkansas Amber. "It's an easy-drinking beer that's great for football season," he said. "We intended for it to be a seasonal, but it was so popular we decided to

keep it year-round." Perhaps the most unique beer that Quattlebaum has brewed—and one that Damgoode planned to take to the 2017 Great American Beer Festival—is Ready, Set, Gose. The German-style sour beer featured a citrusy saltwater character that was popular in the Little Rock market. Other Damgoode beers—which are primarily sold through at the chain's four restaurants—include Honey Hefeweizen, Slam Dunkel, O Quattlebaum (an American IPA that registers 70 IBUs) and Red Leader Irish Ale.

Rebel Kettle Brewing (2016)
822 East Sixth Street, Little Rock

John Lee can thank his Red Rum Pum—an imperial pumpkin ale aged on rum-soaked oak—for providing the spark needed to get things going at Rebel Kettle Brewing Company. Lee's dream of becoming a professional brewer became a reality when he served that particular beer to the right person at the right time one fortuitous night.

Lee started working on the Rebel Kettle concept with his good friend and co-worker Tommy McGhee in March 2013. The two homebrewed together frequently and often contemplated going pro. Casual conversations soon turned into action planning. Lee and McGhee took it slow at first, using social media to test the waters. "Basically it was just an online brewery—Facebook and Twitter—and that was it," said Lee. McGhee sketched a logo featuring a rockabilly skeleton named "Johnny Two-Pints," and the name of the brewery was set. "We're always trying to stretch people's imaginations," said Lee, explaining why the name Rebel Kettle fit the duo's personalities. "The concept was always a rebellion against average beer." The response on social media was better than they could have imagined. People in Little Rock were ready for another brewery to emerge, and Rebel Kettle was generating incredible buzz.

While Rebel Kettle was coming together as a concept, Jason and Kim Polk were working on their own plans for a brewery. The couple was involved in the family business—Lake Liquor in Maumelle, Arkansas—and they were looking for a new venture to pursue. Being on the frontline of beer sales gave them a great feel for the potential of craft beer in central Arkansas. Not only did the Polks develop a strong palate for it themselves, but they also knew that the local market was underserved. There seemed to be plenty of space

for new entrants. So they partnered with longtime friend Matt Morgan and started looking for a brewer to join them on a brewery project.

Through connections in the homebrewing community, Rebel Kettle was able to attend and serve beer at the 2013 Little Rocktoberfest (an annual beer festival hosted by the Centeral Arkansas Fermenters). For Lee and McGhee, it was an opportunity to get in front of the public as Rebel Kettle for the very first time. "They set us up between Core Brewing and Leaky Roof Meadery," said Lee. "We were right there with the big boys." People enjoyed their beer, and success at Little Rocktoberfest led to an invitation to the Arkansas Times Craft Beer Festival a few months later. On that particular day in November, Kim Polk tasted Rebel Kettle's Red Rum Pum for the first time. She shared it with her husband, and they both thought they might have found their brewer in Lee.

A missed call or two and a few months later (Lee is told that he missed voicemail from the Polks after Rocktoberfest, although he doesn't remember it that way), Rebel Kettle was again pouring beer for the public. The 2014 Food & Foam Fest was held at the minor-league baseball stadium in North Little Rock. New Polk associate Shawn Stane teamed up with Morgan with a clear mission: find the guys from Rebel Kettle and set up a meeting. When they found them, they explained the potential for partnership and invited Lee and McGhee to meet the Polks to discuss in detail. "So, we all met at Flying Saucer one night and started shootin' the shit," remembered Lee. "We all got along really well." A deal was struck, and the work began in earnest.

The beefed-up version of Rebel Kettle emerged from that meeting and scoured Little Rock for a place to set up shop. The brewery's owners settled on a building at 822 East Sixth Street, just east of Interstate 30 in downtown Little Rock. The site was the former home of a Jones Truck Lines terminal and was more recently occupied by AC Specialties. Rebel Kettle closed on the purchase of the building midway through 2014 and reportedly invested more than $1 million renovating the six-thousand-square-foot space. Lee said that he initially thought he could keep his job at a local car dealership while working on the startup, but he quickly realized it was an unrealistic expectation. "My wife was pretty nervous going into this," he said. "Especially when I decided to quit my job."

By February 2016, Rebel Kettle was ready to brew. The doors opened to the public on March 25 of that year. A small but amiable shakeup within the partnership team resulted in Lee, Morgan and the Polks (along with a handful of minority investors) emerging as owners of the brewery.

Rebel Kettle Brewing Company renovated a former Jones Truck Lines terminal and opened in March 2016. *Scott Parton.*

Rebel Kettle started out brewing seven-barrel batches. Four seven-barrel fermenters and two seven-barrel bright tanks handled fermentation. Business in the taproom, where the majority of the brewery's output was sold, was brisk. A few months after opening, the brewery added two fifteen-barrel fermenters to provide additional capacity. More Rebel Kettle beer started to appear at tap accounts throughout Little Rock. Food was a priority for the fledgling brewery as well, with a full-service kitchen available for lunch and dinner.

Rebel Kettle is located in a part of town that has seen some recent development activity. Fellow Little Rock brewery Lost Forty is located close by, as is Rock Town Distillery. Traffic has picked up, and the mentality that "a rising tide raises all ships" is certainly true in this industrial section of downtown. Rebel Kettle has turned itself into a destination all by itself by creating a wonderful space (its patio is a warm-weather favorite) and by brewing interesting, high-quality beers. The core lineup includes Working Glass Hero Blonde Ale, Moontower Cream Stout, Easy Roller American IPA and Dirtbag Double Brown Ale. Lee, who handles the majority of the

brewing duties, also enjoys playing around in the brewhouse. Some of his notable one-offs include Headbangers Ball Imperial IPA, Barrel Aged Wake 'n' Flake (a coffee and coconut cream stout) and Red Rum Pum—the beer that, in a way, started it all for Rebel Kettle.

Leap of Faith (2015)
Various Locations (Contract Brewer)

Joe Mains is a well-known figure in the Little Rock brewing community without the benefit of owning his own brewery. The gypsy brewer has bounced around town making beer on other people's systems and, in the process, has raised money and awareness for some of Little Rock's neediest charities.

Mains's great-great grandmother hailed from Germany, and she made all the beer and wine for the family when he was a kid. Brewing beer was very much a family affair, and by fifteen years old, Mains was making beer with his dad. He continued to brew throughout his life, although by his own admission, his brewing pace slowed considerably due to work obligations. After a fractured back ended his career in the U.S. Navy, Mains moved back to Arkansas and spent twenty years working in the medical sales field. After retiring from that job, he rediscovered his zeal for homebrewing. At the urging of friends, he put together Leap of Faith and started making connections.

Mains brewed his beer under the Leap of Faith label on any system that was available (which has thus far included Stone's Throw Brewery, Flyway Brewing Company and Buffalo Brewing Company). According to Mains, he has brewed an average of two half-barrel batches each month since getting started. "I don't need this to pay the bills," he said. "There's no real need for me to open a business." Having financial security has allowed Mains, who practices the Catholic faith, to donate proceeds from his beer to various charitable organizations across Little Rock, including the Humane Society of Pulaski County and the Arkansas Food Bank. Beer and faith are not mutually exclusive for Mains, who completed high school at Subiaco Academy (a Catholic boarding school in the Benedictine tradition) near Paris, Arkansas. "Catholicism and beer have gone hand in hand for a thousand years," said Mains. "In the rule of St. Benedict, monasteries had to be monetarily self-sufficient. Making beer was the way many made enough money to survive."

Some of the more notable beers released by Leap of Faith include Righteous Indignation (a Belgian-style abbey) and a special brew made to commemorate the 2016 presidential campaign. Nasty Women and Bad Hombres IPA was brewed after the third and final debate between Hillary Clinton and Donald Trump. It used wild yeast from one of Mains's friends (and fellow homebrewer) Samuel Atcherson. "It was right when Trump was calling Hillary a nasty woman, and saying how immigrants are bad hombres. And me being a raging leftie, when I heard that a light bulb went off." The beer was the first from Leap of Faith to be offered in the taproom at Water Buffalo Brewing and Gardening Supply in Little Rock.

"I envision eventually having a three-barrel or seven-barrel brewhouse and a small taproom," said Mains. Although he wants to have his own brick-and-mortar brewery, his ultimate goal isn't to become as large as some of the others in Little Rock. He doesn't want to be overly burdened by the administrative side of owning a brewery. "I'm a brewer first," he said. "I'm not a businessman." For now, Mains is comfortable in his role as gypsy brewer. He is independent and is free to brew what, when and where he wants. One thing is for certain, however: Mains will always stay true to his beliefs, which are in perfect harmony with his desire to brew.

Buffalo Brewing Company (2016)
106 South Rodney Parham Road, Little Rock

Nolen Buffalo had just moved home to Little Rock when he started homebrewing. He didn't want to live with his parents, so along with a canine companion, he took up residence on a friend's couch. It was a two-bedroom house that served as quarters for three men and three dogs. "It was winter time when I was there," said Buffalo. "So we didn't have the summer stench going on." It was in that bachelor pad, with his human roommates, that he started tinkering with homebrewing. He got serious about the hobby, however, when he and his father-in-law began partnering on brew days. "It's a social sport," he said. "And we enjoyed making beer together."

Buffalo worked for the Pulaski County Election Commission earlier in his career. It was his job to maintain the systems and hardware related to the election process. "When I got into the election business, there were a whole bunch of new rules that came out of the Bush-Gore craziness," he said. "One of the new rules that was introduced to try and keep that kind of stuff

from happening in the future was to force every precinct in every county in every state to have a way for visually impaired voters to vote in private without assistance." Buffalo used his technical expertise to start a consulting business called Audio Ballots of Arkansas. Even though it was a successful endeavor, his interest in homebrewing dominated his thinking. He was also gaining interest in hydroponics and indoor gardening.

Buffalo Brewing Company is a spinoff of the Water Buffalo, a homebrewing and hydroponic gardening supply shop in Little Rock. *Buffalo Brewing Company.*

In November 2014, Buffalo rolled the dice and opened the Water Buffalo Brewing and Gardening Supply at 106 South Rodney Parham Road in Little Rock. "When I opened my shop, part of my business model was to obtain a brewery permit," he said. Permitting would take some time, however, so he focused on selling supplies to hobbyists. Buffalo also offered classes to the public in an effort to grow interest and general knowledge of homebrewing and gardening.

The brewing permit finally came in late summer 2016. Buffalo built a twelve- by twenty-five-foot outbuilding on an existing concrete slab behind the store and installed a half-barrel SABCO Brew-Magic system inside. He not only brews his own beer there but also allows other brewers to use his system under Buffalo Brewing Company's permit. A taproom in the shop features beer from the brewery, as well as beer from others across the state of Arkansas. "Our brewery is small, perhaps the smallest in the state," said Buffalo.

A group of gypsy brewers called Blood Eagle Brewing recently obtained several three-barrel fermenters in the secondary market and installed them at Buffalo Brewing. The relationship between Blood Eagle and Buffalo is strong. The Viking-themed brewery will make its beer under Buffalo's permit and release it under its own brand name inside the Water Buffalo's taproom. Buffalo said that he hopes to buy a bigger brewhouse in the near future, but will likely always allow for some form of contract brewing on his system—what has become in many regards a true community brewery.

501 Brewing Company (2016)
1350 East Colonel Glenn Road, Little Rock

Like much of Arkansas, Saline County was dry for most of its history. That changed in November 2014 when voters decided that the time was right for alcohol sales. Fortunately for brewers, the change also meant that beer production was allowed inside the county (which is just a short drive down I-30 from Little Rock). Wes Jones, Don Tackett and Alan Tackett took advantage by starting 501 Brewing Company just two years after the law took effect. "When the law passed, we thought we could make our own," said Jones, who is married to Don Tackett's daughter. "We take our family to Destin every year, and while down there one year, we were half-heartedly joking about opening our own place." The jokes soon took on a serious tone.

The three men had only been homebrewing briefly, but they were making excellent beer together. Alan Tackett, who is Don Tackett's son and Jones's brother-in-law, is a biochemist and runs the cancer research lab at the University of Arkansas for Medical Sciences. His research is centered on yeast, which gave the fledgling beer entrepreneurs a jumpstart on flavor profiling and quality control. The first beer they brewed together—a traditional Czech pilsner—was extraordinarily clear and, by all accounts, a faithful representation of the style. That beer built confidence that kept the team motivated to brew even more.

The conversation that started in Destin gained serious traction when Don Tackett purchased a SABCO BrewMagic. The men then applied for their brewing permits, though being the first in a once-dry county led to a long and arduous wait. 501 Brewing Company—as they would come to be known—started brewing in Jones's garage, fine-tuning recipes. With children around and a brewing schedule that was quite hectic, they decided to look for a property to base the brewing operation. Jones and the Tacketts found an out-of-the-way location with a forty- by sixty-foot warehouse space that was perfect for their needs.

501 Brewing Company finally received the necessary licensing in August 2016. The new brewery had already introduced its beer to the public at the Hot Springs Beer Festival and Little Rocktoberfest, but finally, things were official. In the future, the small brewery plans to focus on Saline County instead of sending beer to the bigger markets. 501's flagship beer is Wagtail Wheat, and the brewery also produces Hop Springs Pale Ale and Ghost Imperial Stout (made with ghost peppers). Another beer—Uncle Boozers

IPA—is named for Don Tackett's uncle, who is somewhat of a legend in nearby Glenwood, Arkansas (he eventually sobered up and became a night marshal in the community). Night Marshall Stout is also named for that favorite family member.

501 Brewing Company is a small operation that's fairly content being small. Jones and Don and Alan Tackett are family first, business partners second. Deep down they are homebrewers who still enjoy playing with ingredients and recipe formulations. Yeast strains are a particular interest of theirs based on their backgrounds (Jones also works in the medical field). Although they one day hope to open a small taproom at the brewery, their beer can only be found at tap accounts in the area for now—including the aforementioned Water Buffalo in Little Rock.

Blood Eagle Brewing (2017)

From the hallowed halls of Valhala, an idea sparks forth to change the landscape forever. Five men dare to take upon them the task of bringing a beverage second to none in all the nine realms to those in much need of a good time. What once was a clan of drinkers comes the crash of a giant's hammer.

Those were the first words written on the Kickstarter page for Blood Eagle Brewing. The Viking-themed brewery successfully raised funds for startup, and despite an early setback and a slight change in strategy, it released beer to the public in January 2017.

Blood Eagle was the idea of friends Joe Bartsch, Jared Davis and Jay Ragsdale. The three knew one another through Bartsch's tattoo shop, Dolittle Electric Tattoing, in Cabot, Arkansas. Bartsch and Ragsdale were artists there, and Davis worked as the shop manager. The three started drinking different styles of beer together and soon formed an unofficial drinking club they called the Beerzerkers. They started homebrewing soon thereafter, and quickly realized that Ragsdale had a knack for brewing. One day, the three were having lunch at Vino's, and the discussion turned to an inevitable subject—going pro.

Bartsch, Davis and Ragsdale added partners Eric Sorrells and Matt Crockett, and they named themselves Blood Eagle Brewing. Growing up, Ragsdale was a fan of Thor comics, and Davis was in the military. "I always felt like the Marines are like the modern-day Vikings," said

Davis. The brewery's name is a nod to the warrior mentality of Vikings. "Blood Eagle is the Viking way of handling business." The term refers to a brutal form of execution purportedly used in the ancient Norse world. Blood Eagle Brewing used that kind of imagery mixed with heavy metal influences to introduce itself to the public. The artwork is important, and it tends to feature great detail and sharp lines. "Every bit of our artwork comes from Joey Bartsch's head," said Davis. "Some of the stuff he comes up with blows me away." In addition to being a tattoo artist, Bartsch once designed T-shirts for heavy metal bands.

Blood Eagle launched its crowdfunding campaign in May 2015. The intent was to use the money to purchase equipment and secure a location (most likely in downtown Little Rock). Later in the month, the brewery attended the Hot Springs Craft Beer Festival. The team behind Blood Eagle—with their leather jackets, beards and tattoos—stood out from the other breweries in attendance that day. Blood Eagle poured a black rye IPA and a double IPA from behind a custom bar built to resemble a Viking ship. By the end of the night, everyone was talking about the "heavy metal Viking brewers." Blood Eagle hit its funding goal the next month, with ninety-six people contributing a total of $18,101 (the goal was $15,000).

Several three-barrel fermenters were purchased and things seemed to be moving along. Blood Eagle was close to landing a location, but then issues tripped up the lease agreement and the brewery project slowed to a grind. "We hit the brakes for a while," said Davis. "And then Nolen from the Water Buffalo called." Buffalo obtained his commercial brewing license in the summer of 2016 and was willing to partner with Blood Eagle in a sort of gypsy brewing relationship. The fermenters were moved to Buffalo Brewing Company, and Blood Eagle brewed its first batch on Buffalo's half-barrel SABCO in December. The beer—a Citra hop pale ale called Sitra Cadabra—was released at the Water Buffalo in January 2017. "It's the artist formerly known as Valkyrie," said Davis. "Which was the first beer we ever brewed together."

Davis said that he expects to see the relationship with the Water Buffalo/Buffalo Brewing Company to continue. "We're happy where we're at," he said. "Our relationship with Nolen is great, and as long as we have a good symbiotic relationship where we benefit each other I don't really see us going anywhere. Unless we decide we need to have our own location…." Blood Eagle would definitely like to stand alone at some point, but the pace can be slow for now. Everyone associated with the brand is employed full

time elsewhere. Blood Eagle appears happy making heavy metal Viking beer on someone else's system. Besides Citra Cada, the brewery plans to release Thunder God Double IPA and Tone Loki Farmhouse Ale in the near future.

THE HINTERLAND

Arkansas is much more than just Northwest Arkansas and Little Rock. Even though most of the state's population lives in those two areas, there is plenty to see and do elsewhere. The brewing industry has recently branched out into the hinterland, and there are several places to enjoy a pint or two while exploring the amazing geography and culture of Arkansas.

Gravity Brew Works (2013)
11512 Highway 14 East, Big Flat

Bill Riffle and Tony Guinn met in 1978 while Guinn was attending art school in Columbus, Ohio. The two fell in love, married and later moved to Mountain View, Arkansas, in an effort to reconnect with the land. Riffle and Guinn were also homebrewers. They brewed together frequently, playing with recipe formulations and perfecting the beers they would brew commercially in the future.

After living in Arkansas for a few years and getting to know some of the brewers in the area, Riffle became friends with Omar Castelleron, who was at the time the head brewer at River Rock Brewing Company in downtown Little Rock. In 1999, Catelleron offered Riffle the chance to become his assistant, which he gladly accepted. Riffle's professional brewing career was thus born.

After two years at River Rock, Riffle accepted the head brewer position at Vino's Brewpub. He was immediately successful at Vino's, earning a few medals at the Great American Beer Festival and helping Vino's establish itself as one of the premier beer destinations in Arkansas. He still lived in Mountain View, however, and the ninety-minute commute to work was a grind. His wife had a great job at Blanchard Springs Caverns near their home, so they were never interested in moving to Little Rock full time. So, after ten years on the job, Riffle decided that the drive was too much and it was time to move on. Plus, he was in his fifties at the time, and he knew that if he was ever going to open a brewery of his own he better do it soon. In January 2011, Riffle and Guinn started building a brewery closer to home.

Since Big Flat was in a dry county, Riffle and Guinn looked west on Highway 14 and found a piece of land along the highway. They erected the shell of the brewery in 2012 but took their time with the rest. For about a year, they finished the inside of the structure and worked on obtaining the necessary permits for brewing. In the meantime, they scaled up their homebrewing equipment to the point they were brewing thirty-gallon batches at a time. Riffle and Guinn were wary of outside investments in their business, so they put most of their resources into the building and continued to brew on their homebrewing setup. Converted kegs served as the hot liquor tank and mash tun. They boiled in a fifty-gallon kettle and fermented in half-barrel kegs that had their inner parts removed.

Gravity Brew Works officially opened on November 1, 2013, becoming a rural Arkansas beer outpost in the process. The closest cities of any size are Mountain View and Batesville. "We have some regulars from Big Flat, but most come from Mountain View, Marshall, Mountain Home and surrounding towns," said Riffle. He and his wife brew a wide variety of beers, including a kölsch that is quite popular with locals. "The beer we usually run out of first, though, is our IPA," he said. "We have a lot of different IPAs that we make. We have my wife's recipe, and we have mine. We have an India Red, an India Brown and India Black. We have a Rye IPA and a Belgian IPA. We do a lot of single-hop IPAs, and we do one with our hop bursting technique."

In early 2017, Riffle and Guinn installed a custom-built system that allows for much larger batches. The mash tun is a 150-gallon tank that is elevated above the main floor to utilize gravity for wort transfer. A 110-gallon boil kettle is lifted off the ground by a heavy-duty hoist for gravity feeding into the fermenters. Pumps aren't used in the brewery; beer is pushed into kegs by CO_2. "I don't know any other system like it in the whole world," said

Husband-and-wife team and brewing partners Bill Riffle and Tony Guinn opened Gravity Brew Works in 2013. *Gravity Brew Works.*

Riffle. "There might be a homebrewing system that is similar, but I don't know anything like it on this scale."

There are several transplants in northern Arkansas, and they brought their taste for craft beer with them. In addition to the kölsch and IPAs, popular beers at Gravity Brew Works include Falling Star ESB and Brown-Eyed Girl (which is Guinn's recipe). Riffle said that business at the brewery really picks up during tourist season, when highway traffic is heavier. "People will be driving down the highway and see the sign, and you see their break lights go on," he said. "Sometimes they just back up right there on the highway. They can't believe there is a brewery out here in the middle of nowhere, and they just gotta check it out."

Bubba Brew's Brewing Company (2014)
8091 Airport Road, Bonnerdale

Fifteen minutes west of Hot Springs in Bonnerdale, Arkansas, is Bubba Brew's Brewing Company. The seven-barrel brewery is the result of a partnership between Jayson and Nancy Bass, who run the restaurant side of the business, and head brewer Jonathan Martin, who leads the brewing operations.

At the time of incorporation, Martin was an avid homebrewer and a practicing attorney in Hot Springs. He started Spa City Brewing LLC and came to an agreement with the Basses to operate an onsite brewery in the Bonnerdale sports pub. Bubba Brew's Brewing Company utilizes a seven-barrel brewhouse that was designed and manufactured by American Beer Equipment in Lincoln, Nebraska. The restaurant, known as Bubba Brew's Sports Pub & Grill, provides a raucous backdrop for the many beers Martin brews, which includes Arkie Amber Ale (his very first), Skullcrusher IPA, Sandbar Pilsner, Bubba's Dirty Blonde, 10-Point Buck, Great White (a Belgian witbier), Wilford Oatmeal Stout and Buckshot Pale Ale. Most of the names pay homage to Hot Springs, or to the natural world in general. Martin, who is also an avid kayaker, has been quoted as saying the water in Hot Springs is some of the best in the world.

Bubba Brew's officially opened in December 2014. The brewery picked up as many as forty draft accounts around town and in Little Rock. People began seeing the brewery's old Ford Transit utility bus with side-loaded taps around town and at beer festivals. The brewery with the funny name

Members of Bubba Brew's Brewing Company pose with Jim Koch of Boston Beer Company at GABF. *Bubba Brew's Brewing Company.*

was catching on. So much so, in fact, that Bubba Brew's built a second location on Lake Hamilton in Hot Springs. It contains eight thousand square feet of space and bars on two floors, and can be accessed by car or boat. The site provides Bubba Brew's with prime location inside city limits and speaks to the heart of most Hot Springs natives by being on the water. With everyone associated with the brewery being from Hot Springs, having a presence there was important. "The lake location is actually going to be a Bubba Brew's Sports Pub & Grill," said Martin. "Since they are a separate entity we sell to them just like any other retailer, and no brewing will be done onsite." In January 2017, Bubba Brew's announced a downtown Hot Springs restaurant and taproom was opening in the former Bank of America building at 528 Central Avenue. The plans call for 120 seats inside the pub and substantial space for outdoor dining. Martin said that a small brewing system might be added there eventually.

SUPERIOR BATHHOUSE BREWERY & DISTILLERY (2013)
329 Central Avenue, Hot Springs

Hot Springs, Arkansas, is an interesting sort of place. Early in its history it was a popular vacation destination for gangsters, movie stars and professional baseball players. In many ways, it was Las Vegas before Vegas was a thing. Although gambling was technically outlawed in Hot Springs, city and state officials turned a blind eye. Money exchanged hands in huge quantities at places like the Southern Club and the Vapors. It's fairly well known that Al Capone, Frank Costello, Bugs Moran and Lucky Luciano all made Hot

Springs their "off-season" hangout. They reportedly set their squabbles aside and coexisted peacefully while in town for some R&R.

The city was a trendy place for visitors from all over the country—gangster and non-gangster alike. People came to throw dice, bet on horses at nearby Oaklawn Park (which is still one of the nation's premier horse racing venues) and, increasingly, bathe in the thermal waters of the many downtown bathhouses. For many years, people believed that the waters of Hot Springs had a curative quality that could alleviate many ailments. "Bathhouse Row" along Central Avenue originally emerged in the early 1800s and consisted of several wood-frame buildings. Those structures were eventually replaced by grand bathhouses as the appeal of public bathing grew. The eight that remain today were built between 1892 and 1923 and include—from north to south—Superior, Hale, Maurice, Fordyce, Quapaw, Ozark, Buckstaff and Lamar. After advances in medicine were made and thermal bathing fell out of favor, the bathhouses slipped into decades of abandonment and disrepair. Originally admitted into the national park system in 1921, Bathhouse Row features only one—the Buckstaff—that continues to offer baths, massages and steam cabinets. The others are either closed or serve altogether different purposes.

One of the bathhouses used for another purpose today is the Superior. It was originally built in 1916 by L.C. Young and Robert Proctor. It cost $68,000 to construct the eleven-thousand-square-foot facility. Superior closed its doors in November 1983 and, like so many of the others, frayed around the edges. The National Park Service realized that the future of the Superior, along with the other bathhouses on Central Avenue, was likely something other than bathing. It sought investment and rehabilitation, and for the most part, the bathhouses were eventually saved. They are used in a variety of ways now, including an active brewery inside the old Superior.

Rose Schweikhart moved to Hot Springs in 2011. Around this time, the Superior was going through renovations using private funding solicited by the National Park Service. Schweikhart, who attend music school in England, was a fan of British beers and had been homebrewing upon returning to the United States. On a whim, she asked about brewing with water from the thermal springs (there are forty-seven under the surface of the nearby mountain). One thing led to another, and in 2013, she signed a fifty-five-year lease with the National Park Service for the Superior. In the process, Superior Bathhouse Brewery became the first brewery to operate inside the park system.

The Hinterland

Hot Springs was once known for illegal gambling, but betting on horses at Oaklawn Park has always been allowed. *Arkansas Department of Parks and Tourism.*

Superior Bathhouse Brewery is the first brewery to operate inside a national park. *Arkansas Department of Parks and Tourism.*

Superior opened in July 2013 and was initially a restaurant and bar. Retrofitting for brewing purposes proved to be a challenge. A seven-barrel brewhouse was installed in the men's bath area, and in January 2015, Superior put its first beer on tap for patrons. Brewed with the preheated thermal waters of the mountain, Hitchcock Spring Kölsch was enjoyed by the good people of Hot Springs. Schweikhart believes that Superior is the only brewery in the world using thermal water to brew. The water comes into the building at 144 degrees and is potable, contains very little mineral and is essentially a blank canvas for water chemistry and recipe formulation. Other Superior beers have thus far included Whittington Park Wheat, Superior Pale Ale (SPA), Ouachita Ouild (a Flanders red), Big Black Chocolate Stout and the Beez Kneez (another kölsch). Superior consistently keeps seven of its own beers on tap, with another eleven guest taps from regional and national breweries.

People have been filling jugs with water from Hot Springs for decades. Even non-bathers believe in the water's curative powers. For a brewery to use the water for beer makes perfect sense.

Prestonrose Farm & Brewing Company (2016)
201 St. Louis Valley Road, Paris

Liz and Mike Preston are incredibly smart. In fact, "incredibly smart" might be an understatement of epic proportions. She was once a molecular biologist, and he was a nuclear chemist in the navy. They met in 2007 and fell in love. A few years later, they found themselves in Arkansas running a farm and a small brewery.

After their wedding, Mike accepted a job with Entergy Nuclear, and the couple spent a short time in upstate New York. They never really made the cultural adjustment from California to the East Coast. They yearned to move somewhere friendlier and with a climate more conducive to year-round farming (which was becoming a passion and a career interest). "New York was mostly a cultural issue," said Liz. "East Coast culture is very different from West Coast culture. It might as well be another country as far as the people are concerned." They talked to Entergy about a transfer, and fortunately, there was an opening at another Nuclear One location in Russellville, Arkansas. It wasn't as far south as the Prestons had originally hoped, but they agreed to visit so they could see the area for themselves.

Neither husband nor wife had ever stepped foot inside the state of Arkansas before. They arrived with a preconceived notion that the state was flat and lacked trees and plant life like nearby Kansas and Oklahoma. Little did they know that Arkansas is one of the most ecologically diverse places in the United States. "We came here to visit and our minds were blown," said Liz. "We had no idea that Arkansas's terrain and natural resources were so ridiculously rich." They soon found a Depression-era farm on Craigslist that was once owned by the Rose family. The Roses traveled back and forth between Arkansas and California to farm, which was strikingly similar to the Prestons' own relationship with the Natural State. Nestled between the Ozark and Ouachita Mountains and halfway between Fort Smith and Russellville, the ten-acre farm provided everything they needed to start. "You can put a fence around the state and never need anything from outside," said Liz. "Everything you need to live and have a healthy culture is right here." They named the farm and brewery using their last name and the last name of the original family to settle the property. Many of the old structures were saved and there are plans for revitalization in the future.

Prestonrose Farm & Brewing Company is nestled into the countryside in rural Arkansas. *Prestonrose Farm & Brewing Company.*

A few years before acquiring the farm, the couple learned to make cheese and to brew their own beer. Liz said that her husband appreciates the process but would rather let her handle the creative side of things. "He's a cook, and I'm a chef," she said. The farm is a certified organic operation, and they grow watermelon, cantaloupe, peppers and many other fruits and vegetables from heirloom seeds. The Prestons opened the brewery side of the operation in February 2016 in an eighteen- by twenty-foot metal building on the property. The brewery consists of three forty-five-gallon kettles purchased from Ruby Street Brewing, a supplier of brewing equipment based in Fort

Prestonrose Farm & Brewing Company owners Liz and Mike Preston. *Liz Chrisman,* About the River Valley *magazine.*

Collins, Colorado. The "Alpha" model used by the Prestons is primarily sold to brewpubs and extreme hobbyists who are interested in brewing a barrel at a time.

A beer that fits Prestonrose's philosophy is Heritage Pale Ale. It's simple and straightforward—brewed with a special malt from North Carolina that is very similar to Vienna malt, providing a little more color and depth of

flavor than most pale ales. "I'm proud of that one," said Liz. "It will be the one that will go into town when we start distributing in small volumes in February [2017]."

For now, most of the beer is sold in the small taproom on the farm. Samples are provided, but pints are not available for on-site consumption. Prestonrose is mostly a fill-and-go operation. A few kegs have been sent to the Water Buffalo in Little Rock, and the beer has been featured at a few community events. The relatively small size of Prestonrose's brewery does keep distribution options limited, however. There's just not much beer to go around at this point. An onsite taproom is in the works and will likely be open in mid- to late 2017.

People often confuse Mike Preston for the brewer, mostly because he's an extrovert and fits the stereotypical profile (a big guy with a beard). His wife doesn't take offense to this misperception, however. "Almost all of my adult life I've worked in male-dominated communities," said Liz. "It's not something that shocks me at all. Yes, I am able to be offended. You can say or do something that is so sexist that I would be offended, but not when people just assume that my husband is the brewer." Liz is more laidback and prefers to work in the background. Fortunately, she is able to play that role to perfection at Prestonrose Farm & Brewing Company.

THE SHAPE OF THINGS TO COME

Despite a long absence from the public eye, the Arkansas brewing industry now contributes tremendous value to the state's economy. According to statistics compiled by the Brewers Association, the state's breweries were responsible for a total economic impact of $324 million in 2015 (the last full-year statistics available at the time of this book's publishing). The number of breweries increased from just six in 2011 to twenty-eight in 2016. There are other projects in various stages of planning that will contribute to that number in the future, including Fort Smith Brewing Company and JJ's Beer Garden and Brewing Company in Fayetteville.

Fort Smith Brewing Company (2017)
7500 Fort Chaffee Boulevard, Fort Smith

Van Buren native Quentin Willard played tight end for the United States Military Academy at West Point. As a walk-on, he didn't play many minutes, but he participated in the grandeur of it all, including the celebrated Army-Navy rivalry. He fondly remembers some of the hijinks surrounding the game. "We would prank each other and do different things," he said. "But at the end of the day we were still on the same team."

That was especially true considering how graduates of the two institutions eventually join forces to defend the nation. After Willard graduated, he spent

Fort Smith Brewing Company will open in 2017. *Fort Smith Brewing Company.*

time in various army assignments, including four years in Korea. A brush with destiny occurred in 2005 when he enjoyed his first German beer. "I thought the beer was amazing," he said. "And I thought beer in America sucks!" Traveling the globe exposed Willard to a wide variety of beer, and he really enjoyed what he was finding. On a later assignment in Rhode Island, he got to see the strength of American craft beer during trips to the region's many brewpubs.

By 2014, Willard was back home in Arkansas. He met a local accountant named Brooke Elder through mutual friends, and the two brainstormed ideas for a restaurant or brewery. Micah Spahn, a design engineer for a local tool manufacturer and longtime homebrewer, came on as head brewer. The original business plan for Fort Smith Brewing Company was for a brewpub concept, but financing challenges led the three partners to focus exclusively on brewing. They secured a location in Chaffee Crossing. The 1,500-square-foot space was soon home to a three-barrel brewhouse. Although Fort Smith Brewing Company is still waiting on its brewing permits, Willard said that he hopes to brew eighteen to twenty-four barrels per week once open.

The location itself is a neat connection to Willard's military past. Chaffee Crossing is a commercial redevelopment of the old U.S. Army camp known as Fort Chaffee. The camp was used for many purposes, including military training, a prisoner of war camp and a detention facility for refugees. Elvis Presley famously trained there in 1958.

Once open, Fort Smith Brewing Company will be the first active brewery in the city since the Weidman family operated their brewpub (and later full-scale production brewery) in the late 1990s and early 2000s. Many locals are excited to see that dry spell come to an end. When it finally does, Willard said people can expect to see several beers from the brewery, including Darby's IPA, Miss Laura's Lager, Kumquat Hefeweizen, Blueray Blueberry Ale and Captain's Coffee Porter.

JJ's Beer Garden & Brewing Company (2017)
3615 North Steele Boulevard, Fayetteville

Jody Thornton is somewhat of a hero in the Fayetteville bar and restaurant industry. He managed Hoffbrau Steaks from 1999 to 2001 and helped the restaurant morph from a stuffy suit-and-tie crowd to a boisterous college drinking hole. After leaving Hoffbrau, he joined forces with Matt "Grub" Christie and opened Grub's Bar & Grille just off Dickson Street in downtown Fayetteville. The restaurant burst onto the scene, catering to casual diners by day and Red Bull–and–vodka drinkers at night. In 2008, Thornton set out on his own and opened JJ's Grill in Rogers. His new concept was part comfort food and part sports bar, with a dash of live music to liven things up. It, too, was a hit. Within a few short years, JJ's had a total of eight locations.

"JJ's Grill has continued to watch as the local, regional and national craft beer scene has developed and evolved," Thornton told the *Fayetteville Flyer* in August 2015. "There are some great breweries in Northwest Arkansas that are thriving and JJ's wants to be a part of that community."

With that, Thornton announced his plans for JJ's Beer Garden & Brewing Company. Plans were unveiled for a twelve-thousand-square-foot building that was set to house a restaurant, brewery and the corporate headquarters for JJ's Grill. Brewer Jennifer Muckerman—or "Muck," as she is called around the brewhouse—was hired from Half Full Brewery in Stamford, Connecticut. Muckerman, who is originally from St. Louis and went to school to be an airplane mechanic, was encouraged to look for opportunities after three years in the Northeast. "The whole Connecticut lifestyle was not for me," she said. Her partner was actually the one responsible for finding the opportunity at JBGB, submitting Muckerman's résumé to Thornton's posting for a brewer on ProBrewer.com. Muckerman wasn't sure about Arkansas at first but was sold after visiting the area and meeting with Thornton in person. "It's gorgeous in Fayetteville, and the cost of living is really good," she said. "Plus there's so much outside stuff to do here." Muckerman's credentials also include formal brewing education from Chicago's Siebel Institute and stops at Marble City Brewing Company in Knoxville, Tennessee, and Trailhead Brewing Company in St. Charles, Missouri.

Officially open on May 10, 2017, JBGB features a fifteen-barrel brewhouse manufactured by Specific Mechanical Systems in British Columbia, Canada. Beer is fermented in five fifteen-barrel and four forty-five-barrel fermenters and is further refined in one fifteen-barrel and one

Owner Jody Thornton breaks ground on JBGB in Fayetteville. *JJ's Beer Garden and Brewing Company.*

forty-five-barrel bright tanks. Muckerman said that the fermenters have been modified so that the beer can be carbonated in the same vessels. The goal for the brewery is to supply a JJ's Grill–branded light lager to all of the company's locations and to brew traditional craft beers under the JBGB flag—beers like IPAs, dunkelweizens and porters.

JJ's Grill chief operating officer Myriah Owens said there are big plans for the brewery. "We are expecting an initial output of 3,000 barrels with the space to double if the demand is there." There are several features that set JBGB apart from other breweries in the area. A sand volleyball court and swimming pool define the outdoor area, as does a live music venue that is capable of accommodating 1,200 people. Since it first opened, JJ's Grill has provided a stage for local musicians, booking up to forty-two show per week. The bigger space at JBGB will allow it to accommodate regional and national acts that should draw the crowds.

And as a nod to the homebrewers in the area, JBGB will soon offer a guest brewer program. Each month, two brewers from the community will be able to brew their recipes on the brewery's one-barrel pilot system and have their beers featured in the taproom. "We're excited about giving the people the opportunity," said Muckerman. "It should be fun tasting what they come up with."

BIBLIOGRAPHY

Arkansas Business. "A Brew(haha)." October 4, 1999. www.arkansasbusiness.com/article/66899/a-brewhaha.
———. "More Brew." September 15, 1997. www.arkansasbusiness.com/article/73089/more-brew.
Bona, Becca. "Drink Insider: The Crew at Blue Canoe Brewing Co." *Rock City Eats*, March 26, 2015.
Brantley, Max. "Fort Smith's Knoble Brewery Loving Remnant of Golden Days of Local Beer." *Arkansas Gazette*, March 21, 1976.
Durning, Dan. "Those Enterprising Georges: Early German Settlers in Little Rock." *Pulaski County Historical Review*, June 1975.
Fisher, Leslie. "A Park with a Brew: Superior Bathhouse Brewery and Distillery." *All About Beer* (March 2015).
George, Jeremy L. "Local Brewery Renaissance: A Social History of Small Breweries in the Ozarks." MA thesis, Missouri State University, 2008. Available at Rubber Spider. http://rubberspider.com/ozarkbeer/docs/ozarkbeer.pdf.
Gill, Todd. "JJ's Grill Owner Plans New Brewery and Beer Barden in North Fayetteville." *Fayetteville Flyer*, August 28, 2015.
Hieronymus, Stan, and Daria Labinsky. "Vino's Brewpub." *Brew Your Own* (March 1998).
Johnson, Ben F., III. *John Barleycorn Must Die: The War Against Drink in Arkansas.* Fayetteville: University of Arkansas Press, 2005.
Stewart, Shea. "Refined Ale Begins Self-Distribution." *Arkansas Democrat-Gazette*, February 8, 2011.

Bibliography

Turnver, B.D. *Reports of Cases at Law and in Equity Argued and Determined in the Supreme Court of the State of Arkansas.* Little Rock, AR: Mitchell & Bettis, State Printers, 1882.

Van Zandt, Emily. "For Love of the Beer: Lost Forty Brewery Head Brewer Omar Castrellon Eschews Labels in Search of Good Brew." *Arkansas Democrat-Gazette*, November 25, 2014.

Wagnon, Ted. "Redneck Entrepreneur Bets All on Locally-Brewed Beer." *Arkansas Business*, August 6–19, 1984.

INDEX

A

Apple Blossom Brewing Company 57, 89, 90, 123
Argenta District 115
Arkansas Brewing Company 33, 35, 36, 37, 55
Arkansas Native Brewery Act 56, 57
Ashworth, Carey 100

B

Baldwin, Jefferson 92
Bartsch, Joe 132
Beachboard, John 120
Beard, Ian 116
Bentonville 44, 54, 69, 70, 76, 96, 97, 98, 101, 102, 105, 123
Bentonville Brewing Company 101, 102
Berryhill, Laura 119
Big Flat 121, 135, 136
Bike Rack Brewing Company 90, 96, 97, 123
Black Apple Crossing 103, 104
BLKBOXLabs 85, 94
Blood Eagle Brewing 130, 132
Blue Canoe Brewing Company 119, 120
Bonnerdale 138
Bosco's 41, 49, 56, 80, 110, 111, 123, 124
Boykin, Beau 101
Boykin, Katie 103
Bray, Lacie 79, 91
Brewer, Amber 120
Brummal, Kyle 99
Bubba Brew's 138
Buffalo Brewing Company 128, 129, 130, 133
Buffalo, Nolen 129
Busch, Adolphus 28

Index

C

Cash, Theron 116, 118
Castleberry, Kort 107
Castrellon, Omar 48, 121
Central Arkansas Fermenters 54, 116
Chaffee Crossing 148
Charlson, Jeff 97
Coates, Andy 79, 90, 91
Columbus House Brewery and Taproom 100
Core Brewing Company 65, 74, 76, 90, 115
Core, Jesse 72, 74
Corral, Jason 100
Cowan, Ida 119
Cowan, Patrick 119
Crockett, Matt 132

D

Damgoode Brews 123, 124, 125
Davis, Jared 132
Diamond Bear Brewing Company 56, 61, 115

E

Edwards, Gavin 101
8th Street Market 98
Elder, Brooke 148

F

Fayetteville 37, 39, 44, 45, 46, 47, 52, 53, 54, 55, 57, 69, 71, 72, 74, 76, 77, 78, 80, 81, 82, 83, 85, 88, 89, 90, 92, 100, 110, 116, 123, 124, 147, 149
Fayetteville Lovers of Pure Suds 46, 52
501 Brewing Company 131, 132
Flyway Brewing Company 65, 113, 128
Fort Smith 23, 24, 25, 26, 36, 37, 38, 40, 52, 53, 54, 55, 74, 76, 87, 143, 147, 148
Fort Smith Brewing Company 147, 148
Fossil Cove Brewing Company 82, 86
Foster, Matt 113
Foster's Pint & Plate 99
Fretheim, Elizabeth 97

G

Gallaspy, Will 80, 110
George, Alexander 22
George, Henry 22
Gilliam, John 37, 44, 45, 46, 71
Gilliam, Maggie 44
Gravity Brew Works 135, 136, 138
Gray, Windell 111
Griffiths, John 46, 52
Guinn, Tony 121, 135

H

Handley, John 103
Hildenbrand, Phillip 26
Hog Haus Brewing Company 47, 71, 75, 88, 89

Index

Holt, Trey 103
Hot Springs 16, 54, 59, 60, 114, 122, 131, 133, 138, 139, 140, 142

J

JJ's Beer Garden & Brewing Company 149
Jones, Wes 131

K

Kling, Charles 63
Knoble, Joseph 23, 25, 26, 36, 38, 40, 87
Kupferle, Nick 28

L

Lange, Joey 97
Langley, Michael 56
Larson, Kari 47, 71
Leap of Faith Brewing Company 128, 129
Lee, Henry 40, 55
Lemp, W.J. 28
Letellier, Casey 80
Little Rock 17, 22, 23, 26, 28, 30, 31, 33, 35, 40, 41, 42, 43, 47, 48, 49, 54, 55, 59, 60, 61, 62, 64, 65, 76, 80, 90, 96, 109, 110, 111, 112, 113, 115, 116, 118, 119, 120, 121, 122, 123, 124, 125, 126, 127, 128, 129, 130, 131, 132, 133, 135, 136, 138, 145

Little Rock Brewing & Ice Company 30
Loman, Kasey 101
Lost Forty Brewing Company 121
Lyon, William 33, 34, 36

M

MacArthur Park Historic District 116
Mains, Joe 128
Martin, Jonathan 138
Mazylewski, Steve 72
McDonald, Evan 57, 89
McDonough, Russ 120
McEnroe, Derek 105, 106, 107
McGehee, Scott 120
McGhee, Tommy 125
McLaurin, Brad 116
McMullen, Jess 113
Melton, Jesse 64
Melton, Russ 56, 59, 64
Mills, Ben 82
Mong, Ching 90
Moody Brews 42, 90, 98, 122, 123, 124
Moody, Josiah 42, 98, 122, 124
Moore, Chris 99
Moore, Katie 99
Morgan, Matt 126
Morgan, Sam 100, 101
Muckerman, Jennifer 149

N

New Province Brewing Company 105

INDEX

Nielsen, Andy 97
North Little Rock 64, 65

O

Orpin, Leo 103
Outain, Steve 97
Ozark Beer Company 80, 91, 92, 93
Ozark Brewing Company 44, 45, 46, 47, 53, 55, 56, 61, 71

P

Paris 128, 142
Pickop, Ryan 80
Polk, Jason 125
Polk, Kim 125, 126
Preston, Liz 142, 143, 145
Preston, Mike 142, 145
Prestonrose Farm & Brewing Company 142, 145

Q

Quattlebaum, Josh 110, 123, 124

R

Ragsdale, Jay 132
Rebel Kettle Brewing Company 125
Refined Ale 111, 112
Rehbock, Steve 86, 87, 88, 89
Riffle, Bill 42, 48, 121, 122, 135

Riley, Scott 33, 34, 36
River Rock Brewery 47, 48
River Valley Ale Raisers 53
Robinson, Lee 101
Rogers 69, 70, 75, 80, 91, 93, 96, 99, 105, 124, 149

S

Saddlebock Brewery 73, 86, 89
Saline County 131
Schaffer, Al 89
Schmuecker, John 77
Schneider, Emanuel 28
Schweikhart, Rose 140
Sill, Julie 47, 71
Smith, Daniel 90
Snyder, Vic 43, 55
Sorrells, Eric 132
Spahn, Micah 148
Sparks, Andy 85
Spencer, James 85, 90
Springdale 69, 73, 74, 75, 76, 86, 90, 103, 104
Stane, Shawn 126
Stephenson, Sammie 89
Stone's Throw Brewing 22, 23, 54, 116, 117
Superior Bathhouse Brewery & Distillery 139, 140

T

Tackett, Alan 131, 132
Tackett, Don 131, 132
Tanglewood Branch Brewing Company 80, 82

156

INDEX

Thornton, Jody 149
Tobin, Shawn 116
Traw, Nathan 90

U

University of Arkansas 77, 98, 100
University of Arkansas–Fort Smith 76
Utsch, Joe 89

V

Vino's Brewpub 40, 98, 136

W

Wampler, J.T. 80
Ward, Marcus 90
Water Buffalo, the 129, 130, 132, 133, 145
Weidman, Bill 37
Weidman, Daniel 37, 38, 39, 74
Weidman, Peggy 37
Weidman, Shaun 37
Weidman's Old Fort Brew Pub 36, 38, 55, 74
Weidman, Terry 37
West Mountain Brewing Company 77, 78, 80, 90, 92, 110
Willard, Quentin 147
Wortz, Carl, Jr. 26, 38

Y

Youngblood, Brian 90

Z

Zucca, Joe 97, 98

ABOUT THE AUTHOR

Brian Sorensen is a freelance writer based in Fayetteville, Arkansas. His work has appeared in the *Fayetteville Flyer*, *All About Beer* magazine and *Southwest Brewing News*. The University of Arkansas graduate is a human resources director for a Fortune 100 company based in northwest Arkansas. His gateway beer was Sierra Nevada Stout, and he learned to brew by way of the Methodist Church (true story). Sorensen enjoys traveling to beer destinations across the world with his wife, Megan.

Visit us at
www.historypress.net

This title is also available as an e-book